kittenhood

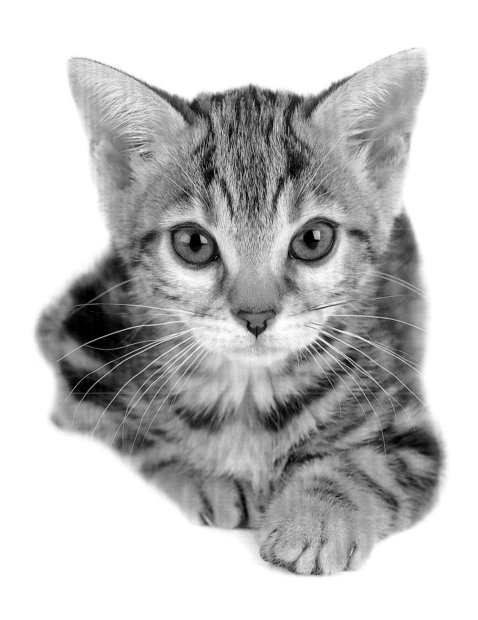

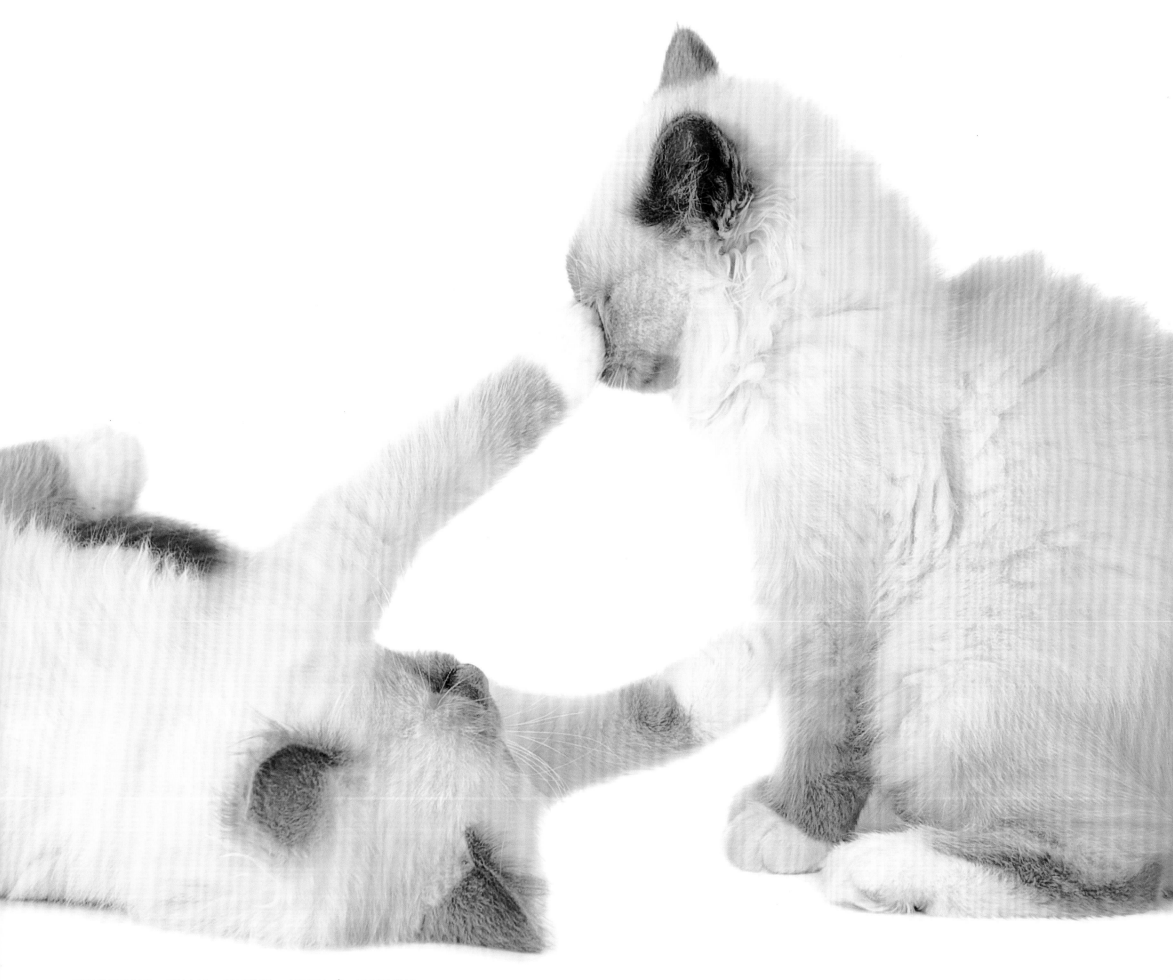

PREVIOUS: KHAN **ABOVE:** JOEY & JAXSON

kittenhood

life-size portraits of kittens in their first 12 weeks

SARAH BETH ERNHART

stewart tabori & chang

New York

Published in 2013 by Stewart, Tabori & Chang
An imprint of ABRAMS

Cataloging-in-Publication Data has been applied for and may be obtained from the Library of Congress.

ISBN: 978-1-61769-057-0

Editor: Samantha Weiner

Kittenhood is produced by becker&mayer!, Bellevue, Washington.
www.beckermayer.com

Photographer: Sarah Beth Ernhart
Author: Sarah Beth Ernhart
Editor: Leah Tracosas Jenness
Designer: Katie Benezra
Design Assistance: Megan Sugiyama, Bri Graff
Photo Editor: Kara Stokes
Managing Editor: Nicole Burns Ascue

Printed and bound in Hong Kong, China

10 9 8 7 6 5 4 3 2 1

Stewart, Tabori & Chang books are available at special discounts when purchased in quantity for
premiums and promotions as well as fundraising or educational use. Special editions can also be
created to specification. For details, contact specialsales@abramsbooks.com or the address below.

115 West 18th Street
New York, NY 10011
www.abramsbooks.com

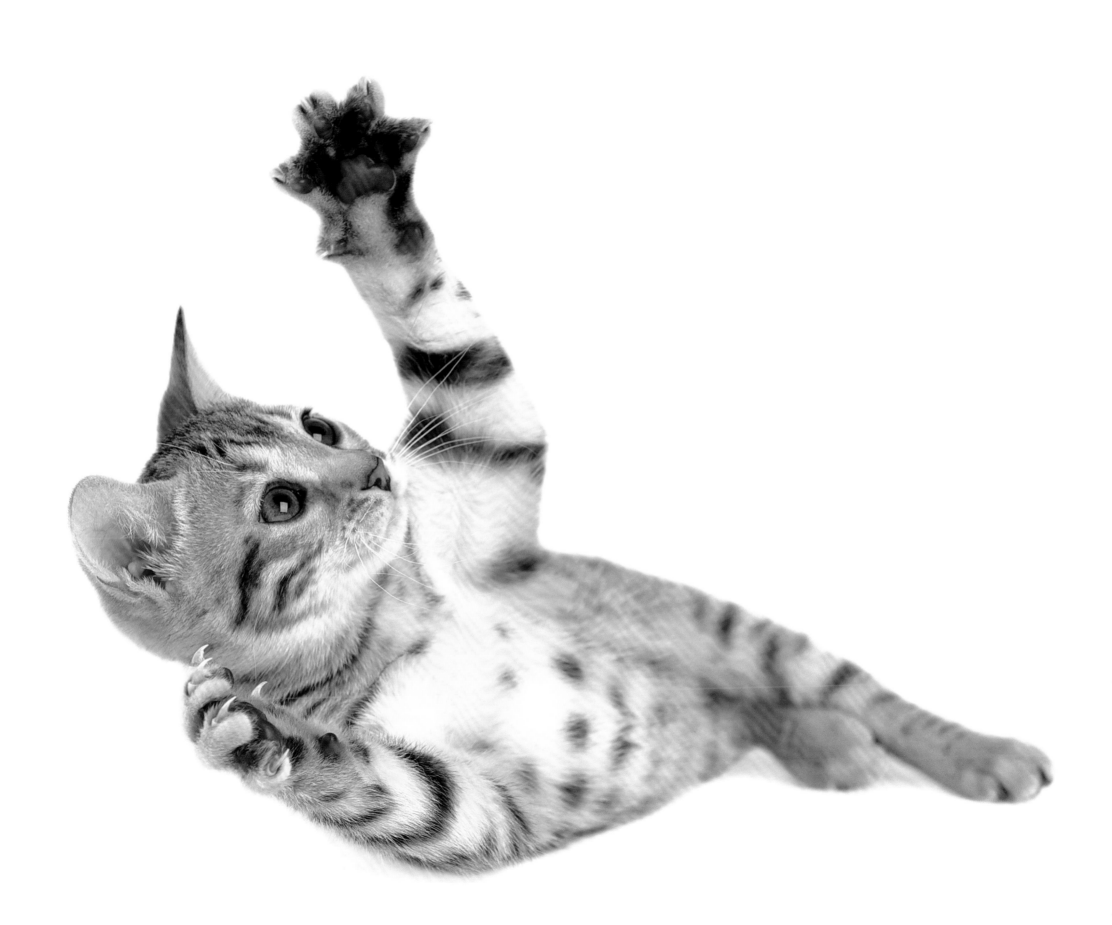

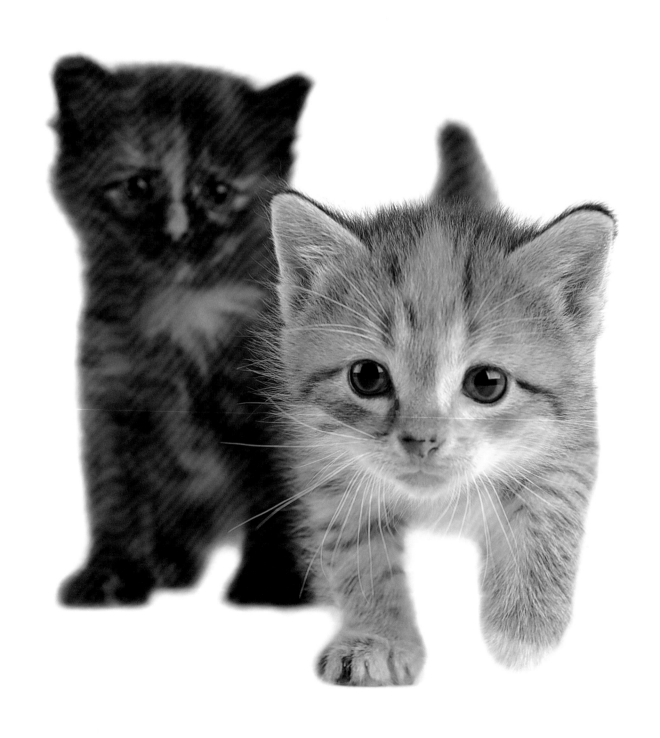

breed list

RagaMuffin

Maine Coon

Cornish Rex

Tuxedo Mix

Birman

Oriental

Bengal

Tonkinese

Exotic Longhair

Sphynx

Black Mix

Napoleon

Ocicat

American Curl

Selkirk Rex

Burmese

Siberian

Siamese

Tortoiseshell Mix

Himalayan Persian

American Shorthair

Devon Rex

Tabby Mix

Bombay

Persian

introduction

I've always been a cat person. I grew up on a farm, spending my youth in the barn with countless litters of kittens, building trust, learning about their development and behavior. Without fail, kittens are curious and funny, fuzzy and cute. As I was photographing this book, I was reminded of kittens from my past, and my love for these unique little creatures was renewed. Every day is a new adventure for them; they are carefree, exploring the world, perfecting their hunting skills through play, testing the limits of their balance and coordination. Kittens are a delight to watch, to play with, and to snuggle with. The best part of their day (or maybe of yours) may be simply chasing a string dragged across the floor.

This book highlights twenty-five different types of kittens, both mixed-breed and purebred, photographed at life size. You'll see many universal, precious kitten qualities in the different breeds: fuzzy paws, big ears, tiny wet noses, wiry little tails, snuggly bodies, and wide, curious eyes.

And yet as much as they have in common, each type has distinctive qualities that define the breed and make them unique and adorable: the elongated faces and elegant bodies of the Oriental; the intense, wide-set eyes and shiny coat of the Bombay; the incredibly soft fluffiness of the Persian and Siberian; the deep blue eyes and soft markings of the Siamese and Birman; the bold tiger stripes of a mixed-breed tabby or the patchwork coat of a mixed-breed tortie. You'll see many diverse manifestations of feline characteristics in a rainbow of kitten colors.

The kittens we photographed for this book range in age from three to twelve weeks, a critical period of rapid physical and social growth for young cats.

The younger kittens are only just starting to learn about the world around them. They don't know about toys, they don't sit still, they're not interested in anything you're doing or want them to do. Their wobbly, fuzzy bodies aren't quite coordinated—yet can be surprisingly fast when they've determined where they want to go. A kitten's first few weeks can be critical to his or her confidence and socialization; if kittens are not handled by humans regularly, they tend to be very nervous about new environments and experiences.

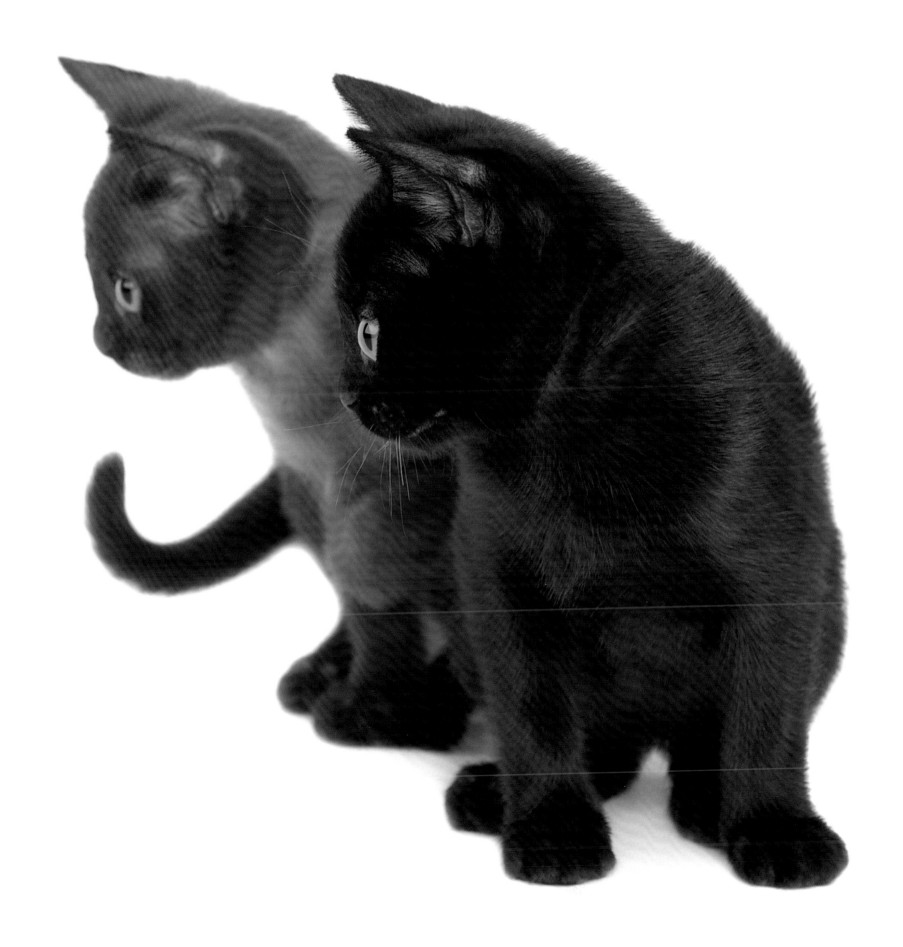

At around six weeks, kittens generally have mastered their bearings and sense of balance, and they're learning how to play. Each litter we visited was different in its interest and willingness to interact. Toys could be the most amazing things ever, or totally frightening. Large, shiny ribbons on a stick were sometimes too much, but small, fur-covered toys might not be enough. Generally, staying calm and quiet and making just small, subtle movements were best when interacting with these kittens.

The older kittens, between nine and twelve weeks, were definitely the most entertaining—rambunctious, athletic, all-over-the-place kittens, many ready to go to their new homes shortly after our shoot.

We were able to see some of the same breeds of kittens at different stages of development. They grow so quickly from helpless, mouselike babies to agile, acrobatic felines—and many of them transform drastically from birth to twelve weeks (and on to adulthood), changing their eye color, their fur color, and in the case of the American Curl, even the shape of their ears.

Regardless of the kittens' ages, our photo sessions were always hilarious. I've photographed puppies that get tuckered out and will fall asleep virtually anywhere. Not so with kittens. These sessions were generally full of unbridled, crazy kitten energy: scrambling, fuzzy, fluffball bodies and frizzed-out tails; pouncing, wrestling, playing, mewing; slow-moving, tentative paws reaching for a new toy; leaping and bounding and falling and rolling; the wild look in their eyes before clobbering a littermate or bouncing off across the room. The seamless white paper background we used during the shoots sometimes ended up being the most fun toy of all: Kittens chewed on it, played hide-and-seek behind it, or leaped at the back of the paper to slide down the curve in the backdrop.

But as I lay on the ground to photograph my subjects at their level, the sweetness of each kitten would get me every time: the featherlight, tiny claws walking on my back; their little noses and whiskers; their soft little paws; a purring kitten curling up in my assistant's lap.

I invite you, as you flip through these pages, to soak in every paw, every whisker, every personality captured here within the fleeting moments of kittenhood.

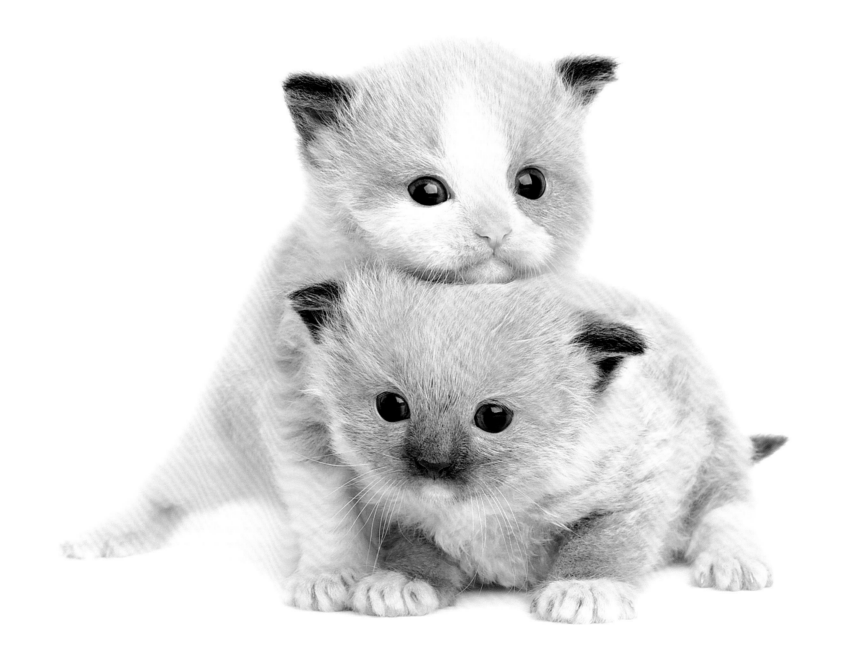

MOLLY & MILO

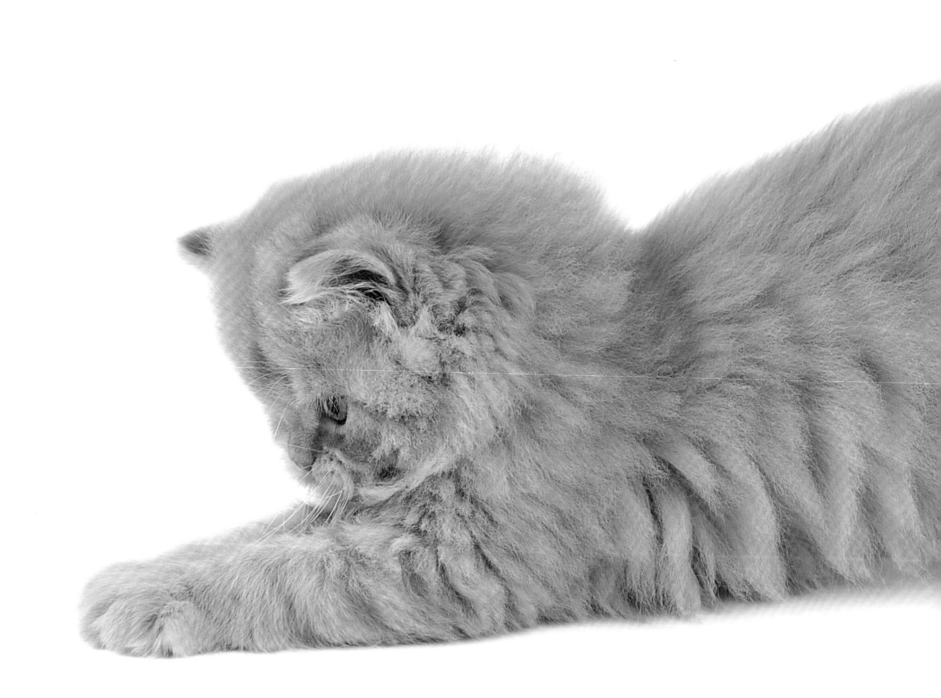

TIGGER

janey | RagaMuffin: 6 weeks, 1 lb

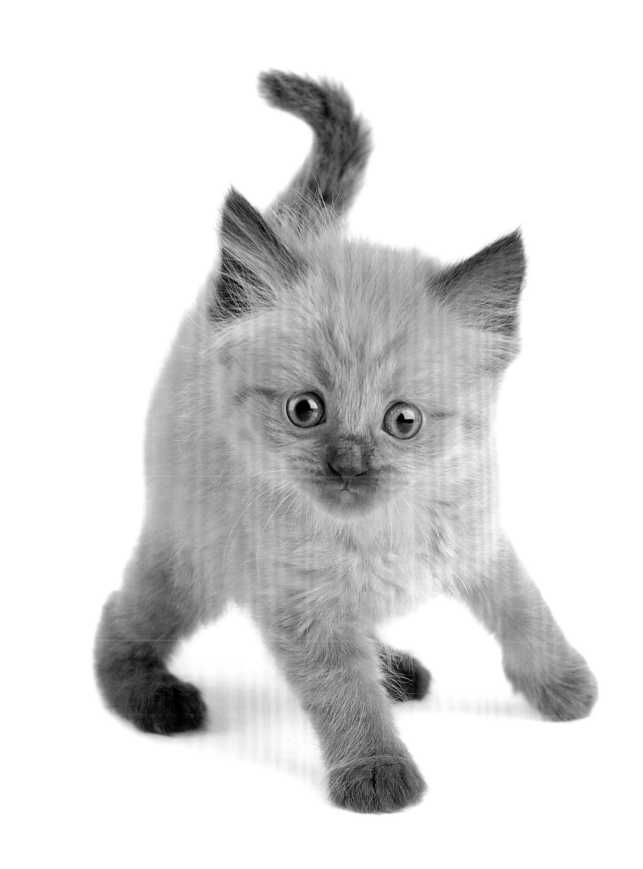

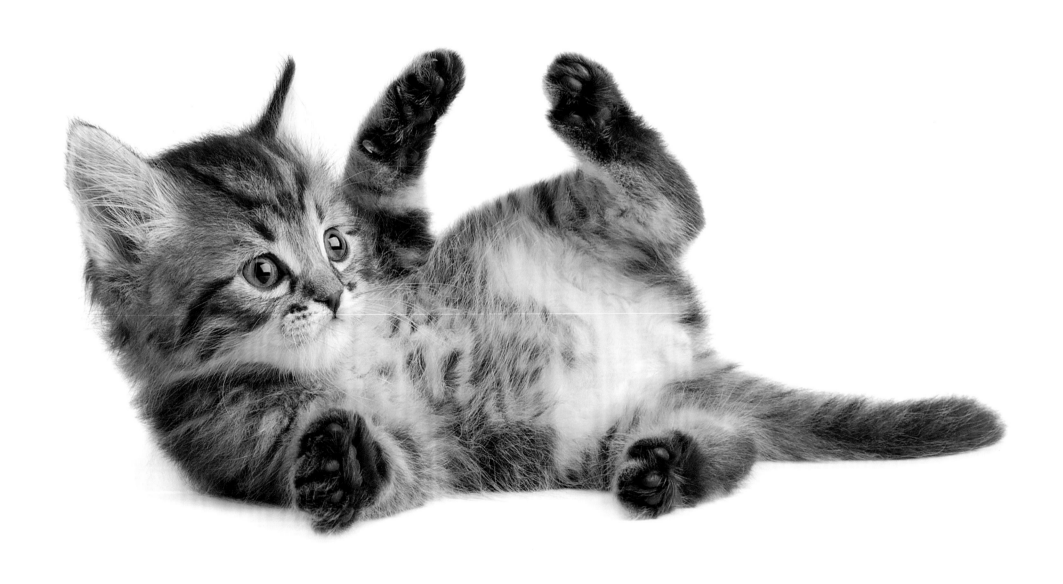

ABOVE: NEWT OPPOSITE: SALLY

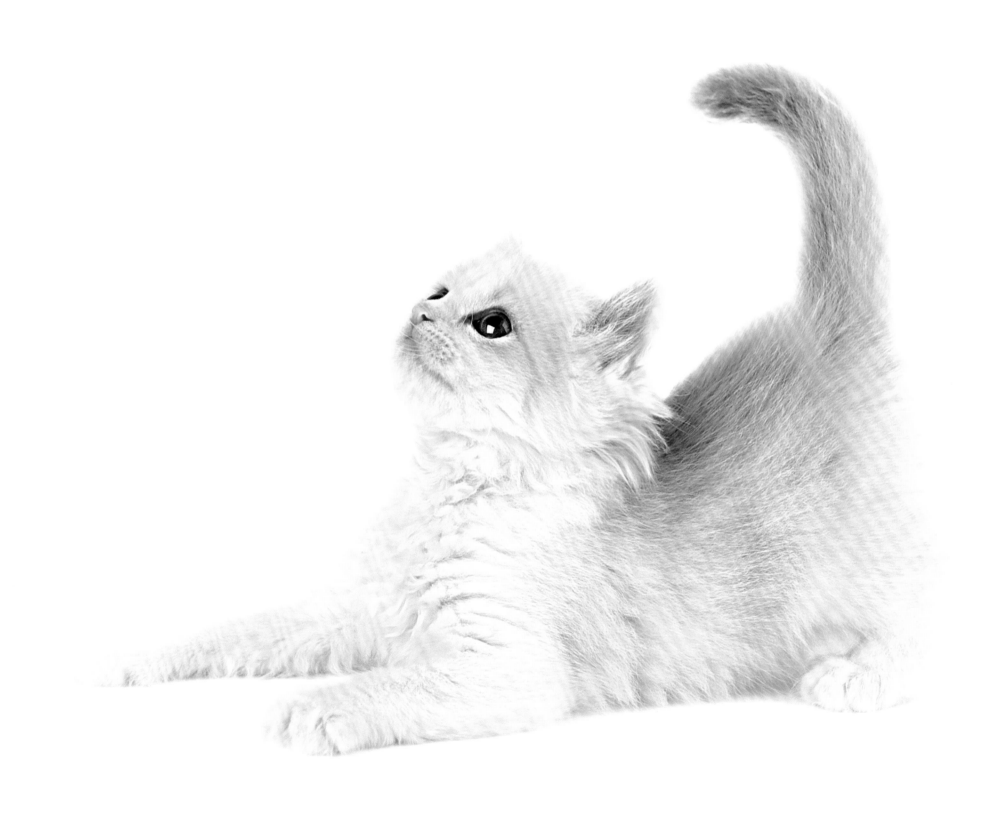

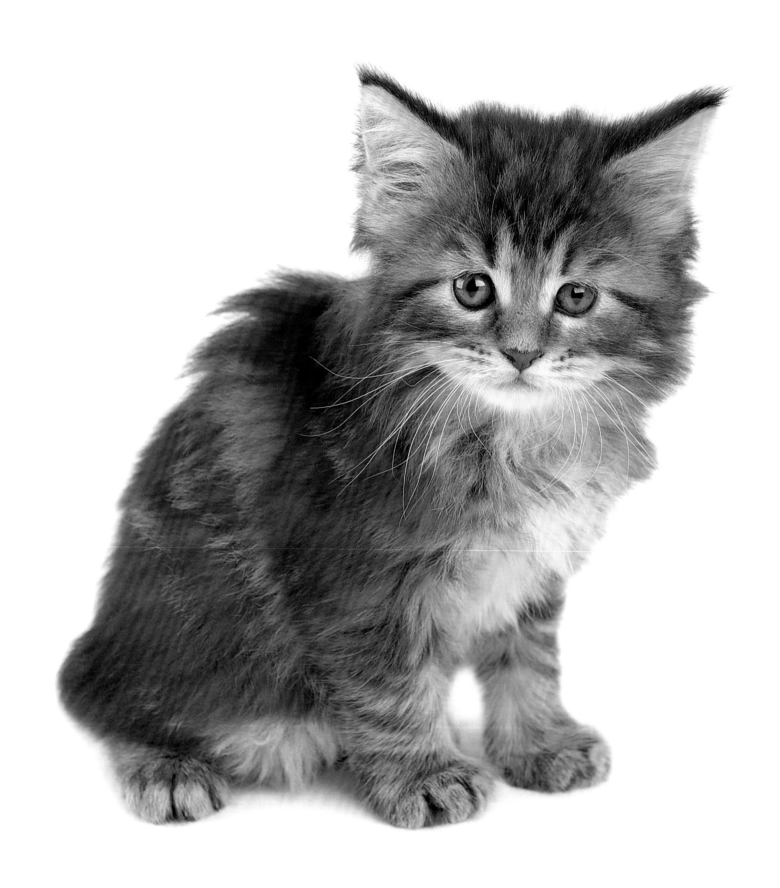

allison | Maine Coon: 5 weeks, 1.9 lbs

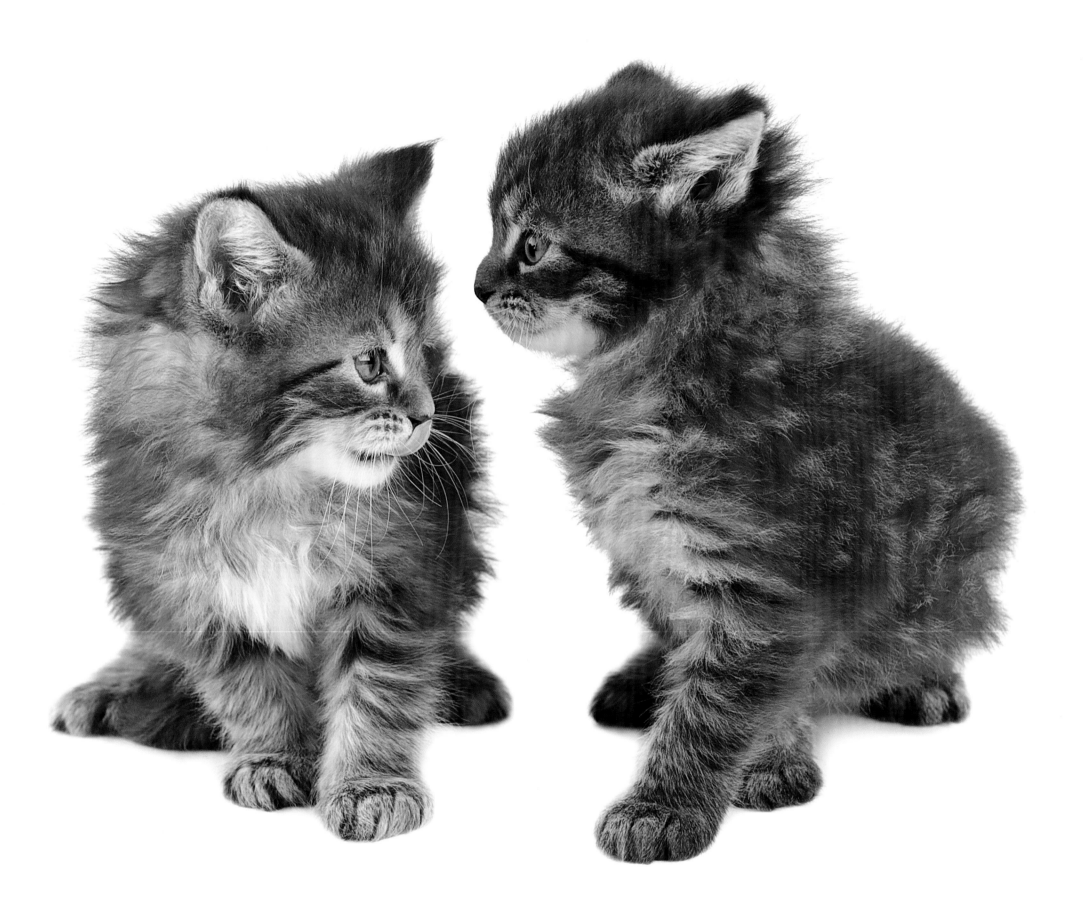

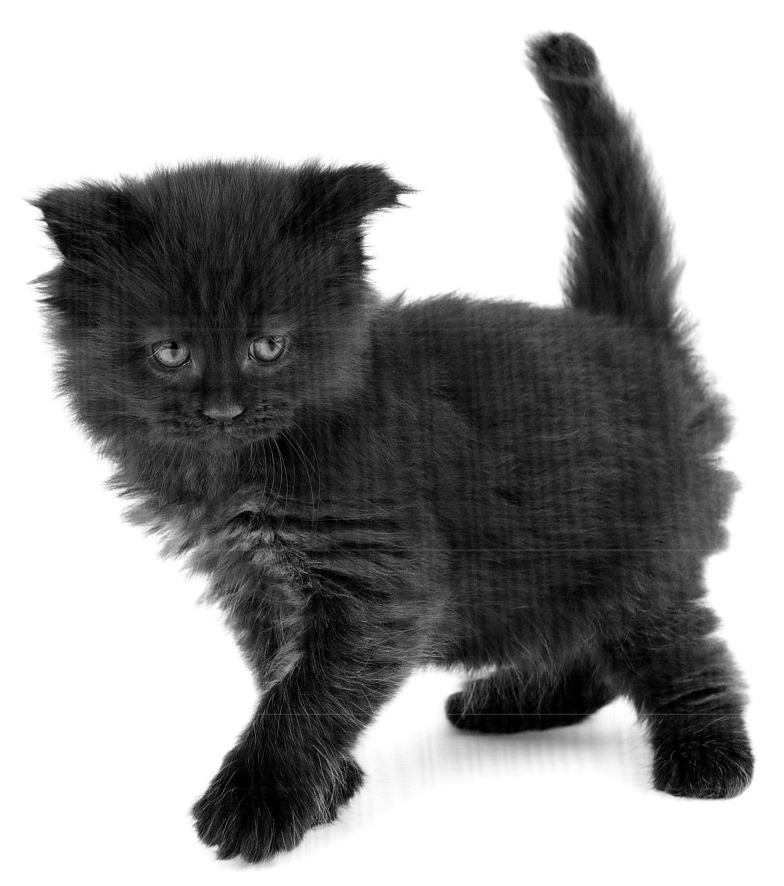

OPPOSITE: ALLISON & MATTI ABOVE: TESSA

ciseley | Cornish Rex: 12 weeks, 2.1 lbs

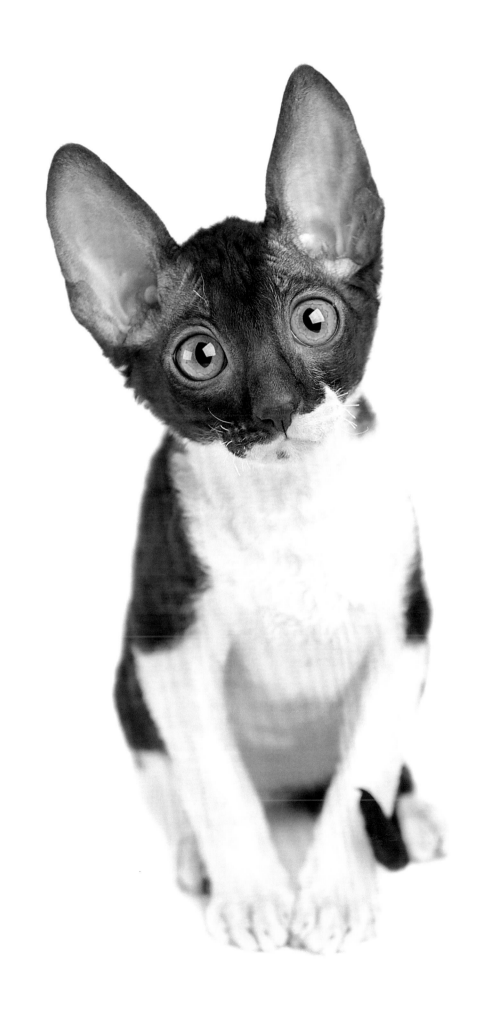

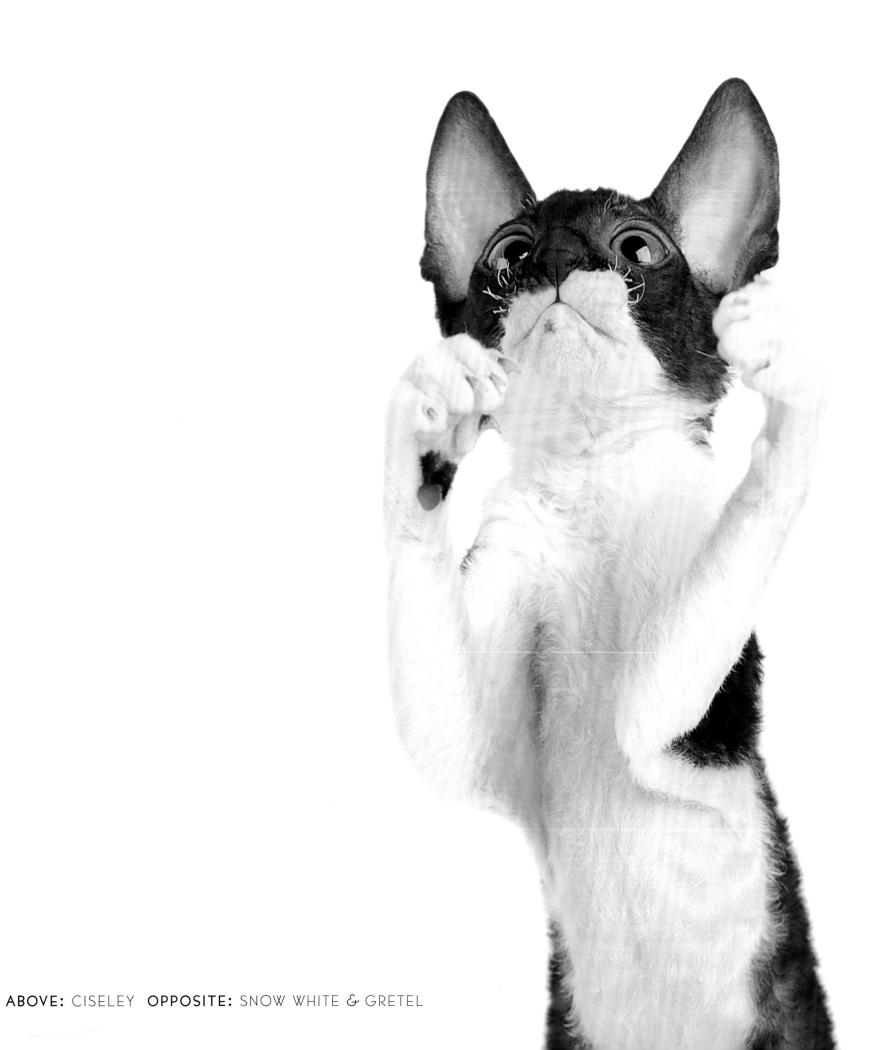

ABOVE: CISELEY OPPOSITE: SNOW WHITE & GRETEL

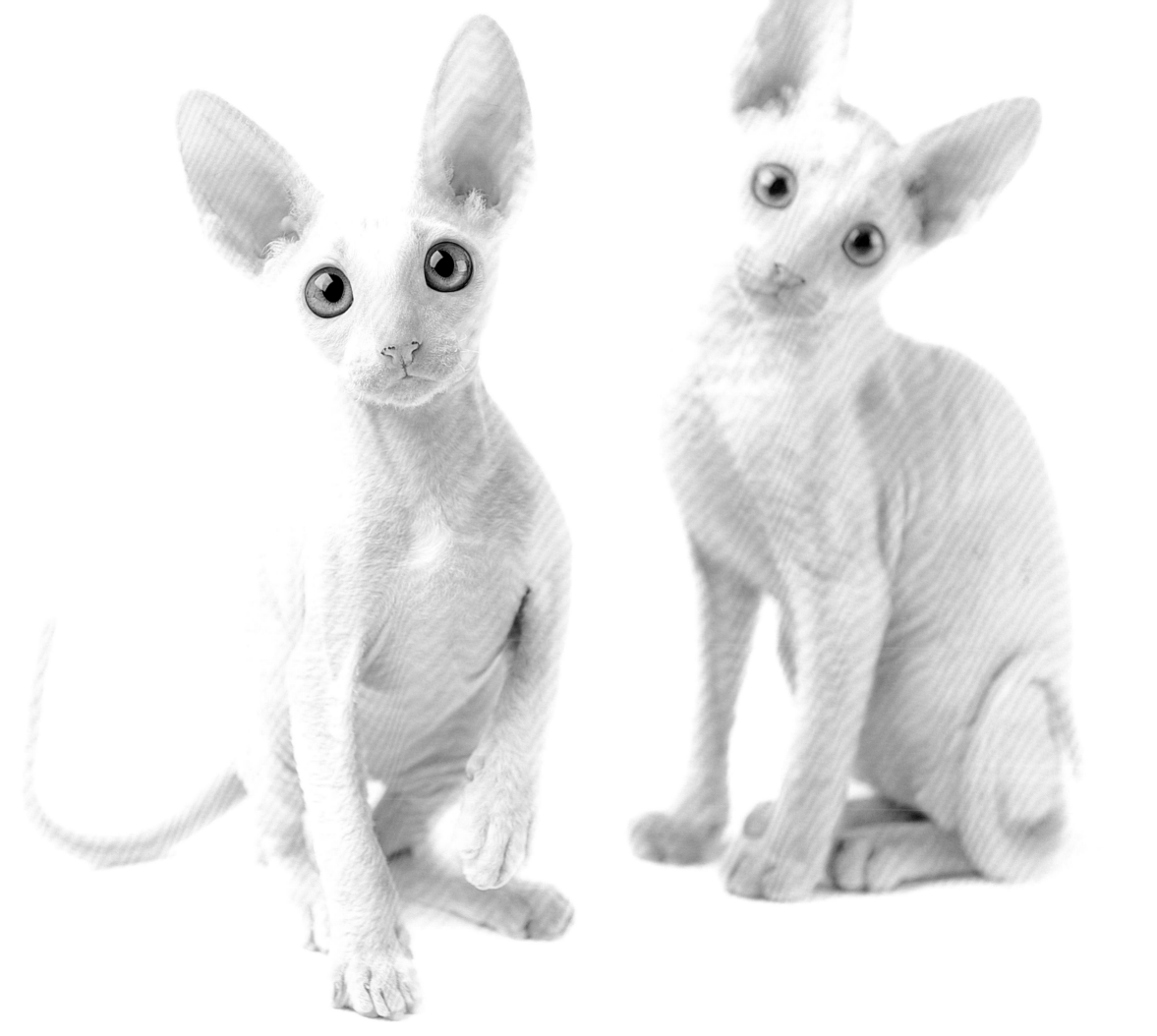

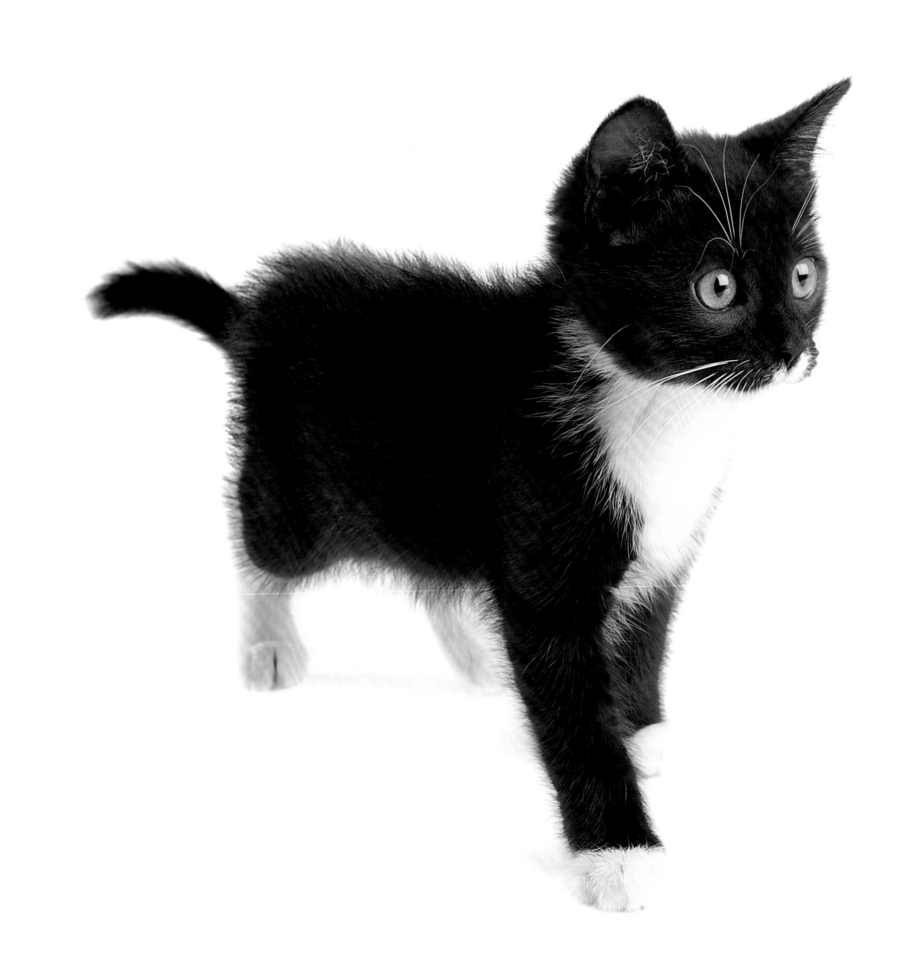

waylon | Tuxedo Mix: 9 weeks, 2 lbs

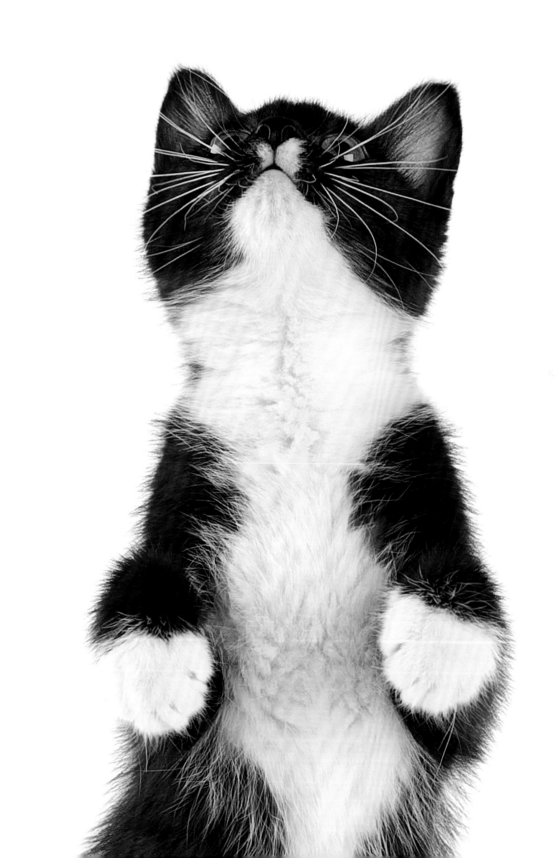

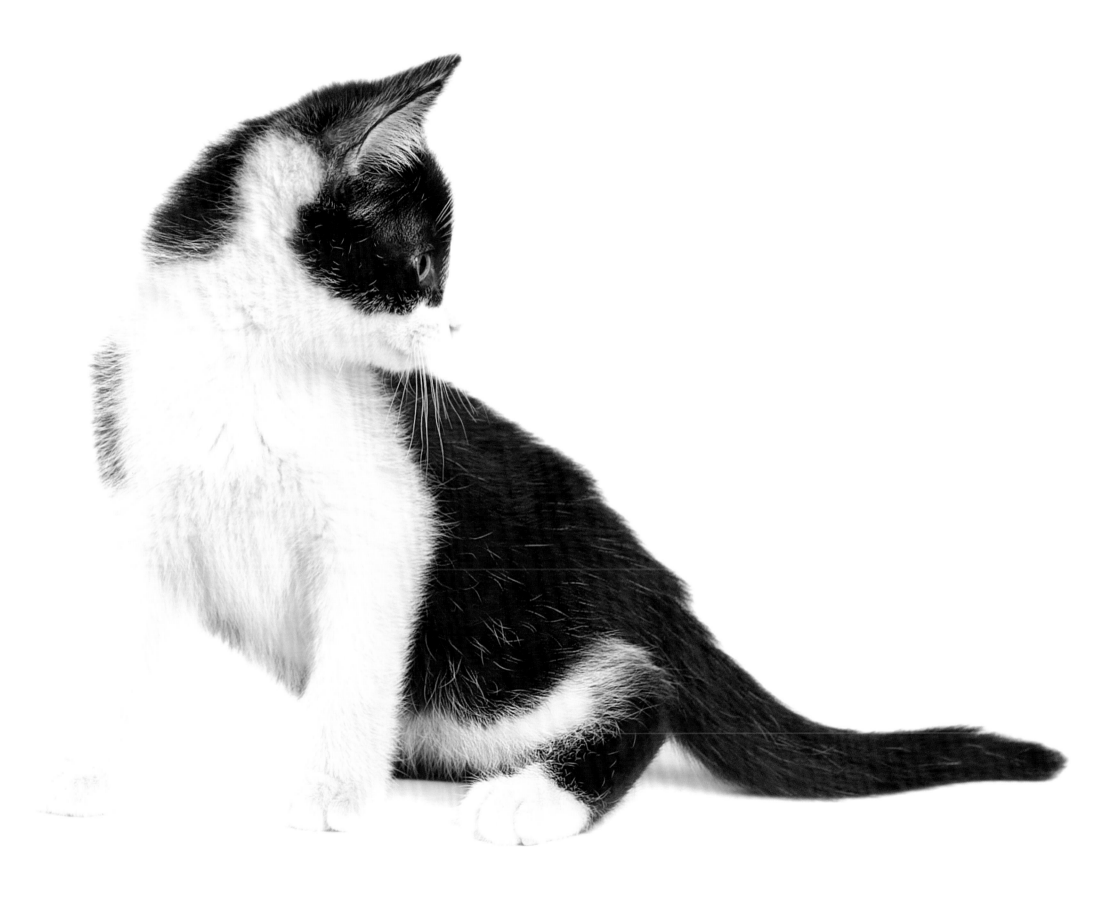

OPPOSITE: WAYLON, 9 WEEKS ABOVE: OREO, 8 WEEKS

joey | Birman: 11 weeks, 3 lbs

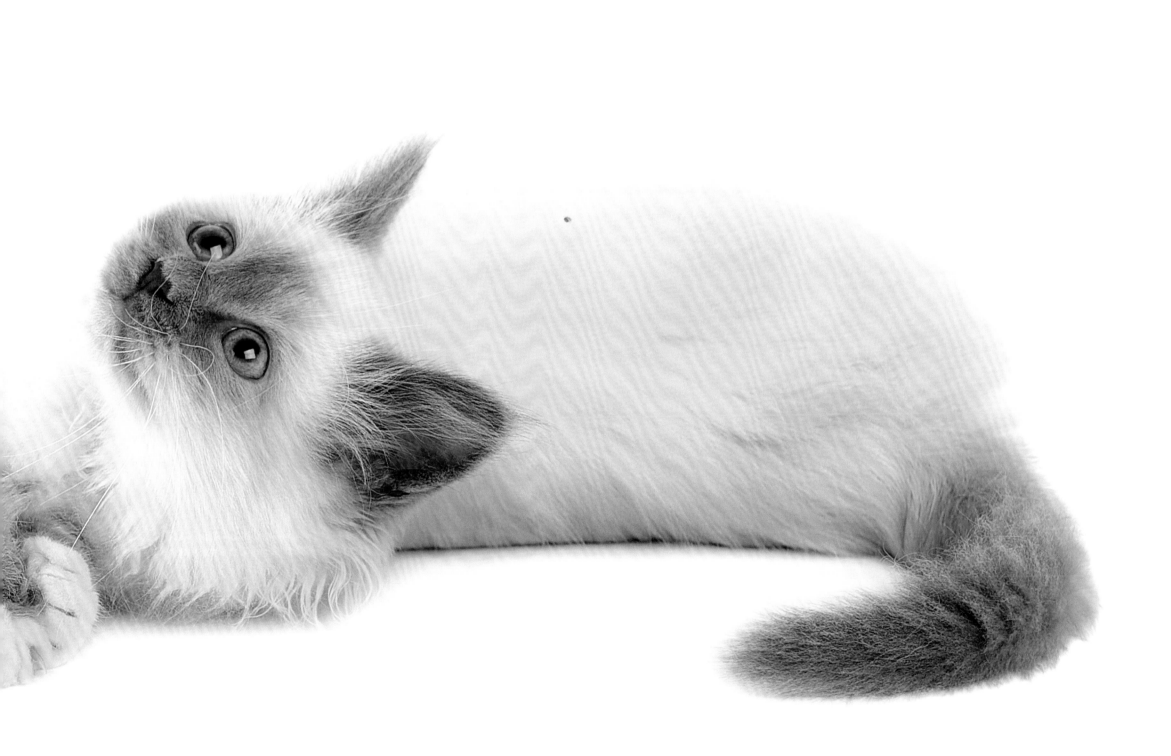

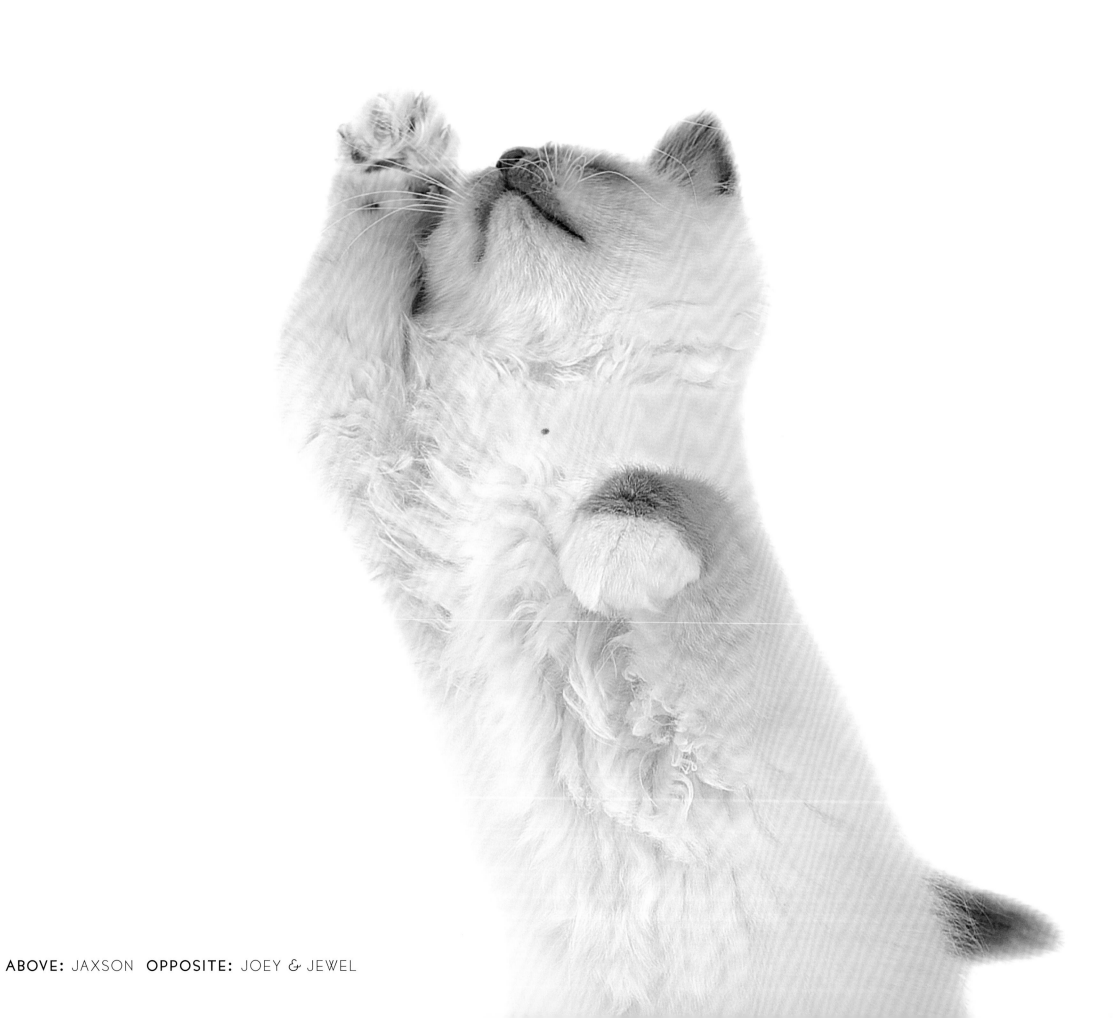

ABOVE: JAXSON OPPOSITE: JOEY & JEWEL

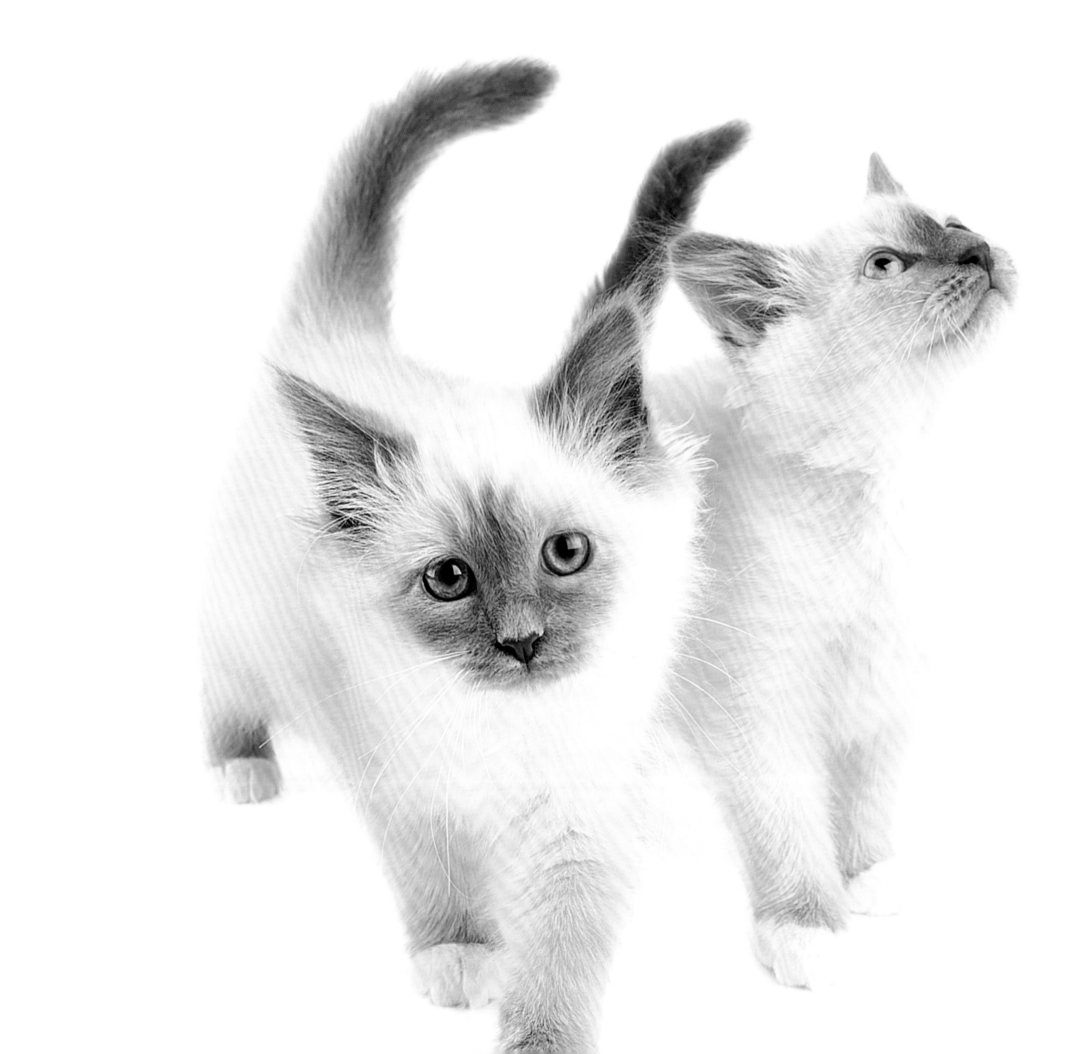

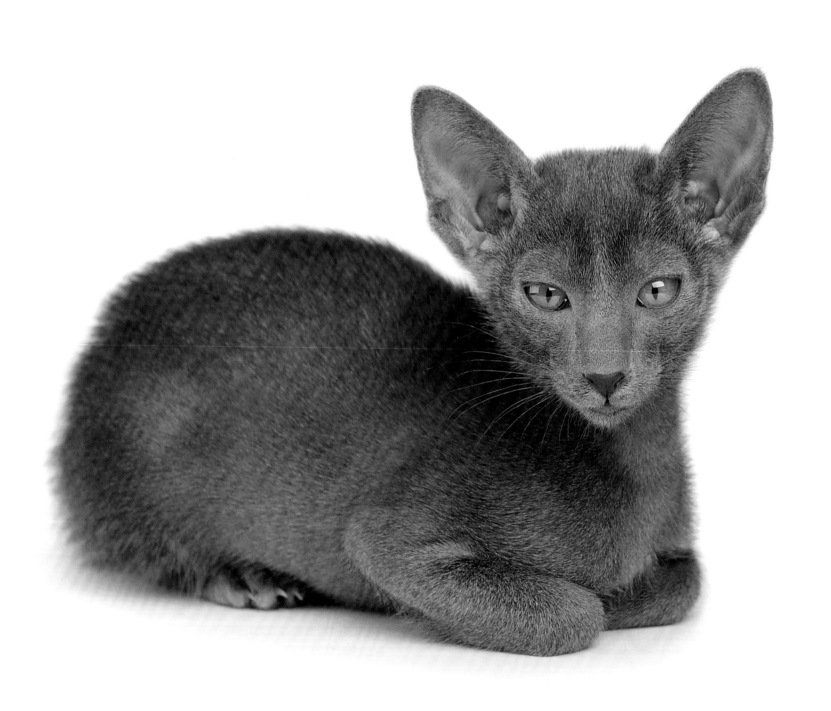

true blue | Oriental: 12 weeks, 1.75 lbs

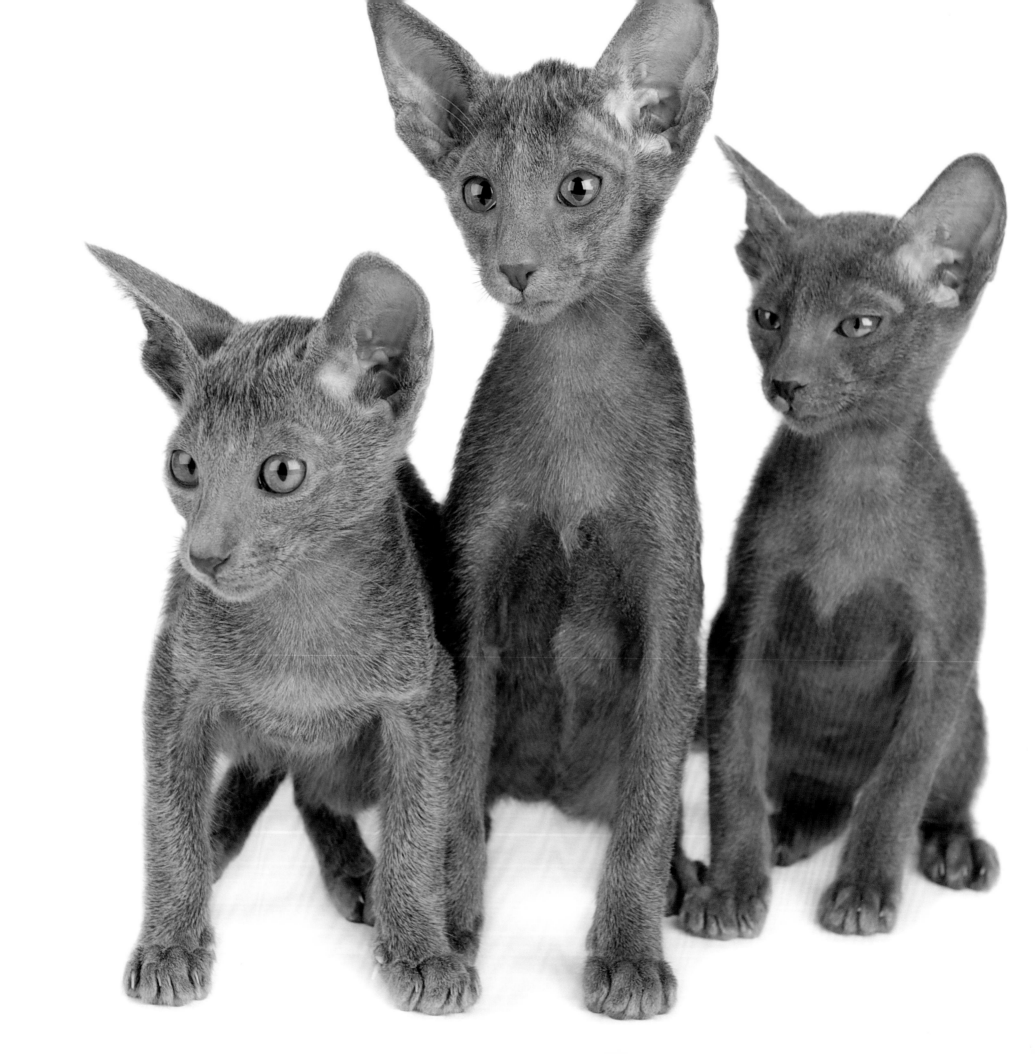

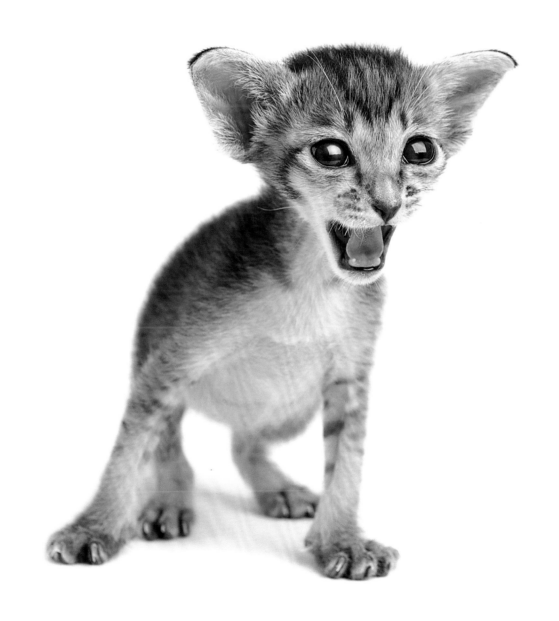

OPPOSITE: SOUND OF THUNDER, TRUE BLUE & BLUE THUNDER, 12 WEEKS ABOVE: OSCAR, 3 WEEKS

khan | Bengal: 12 weeks, 2.9 lbs

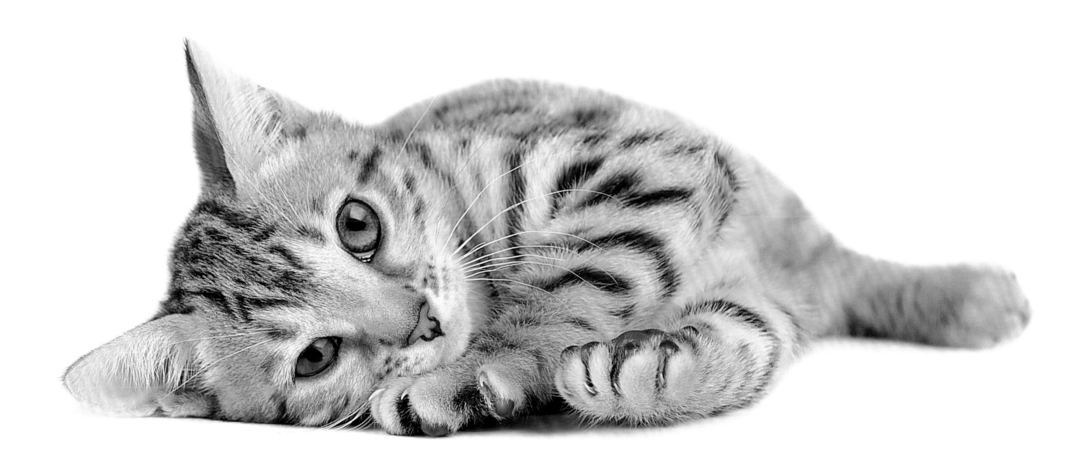

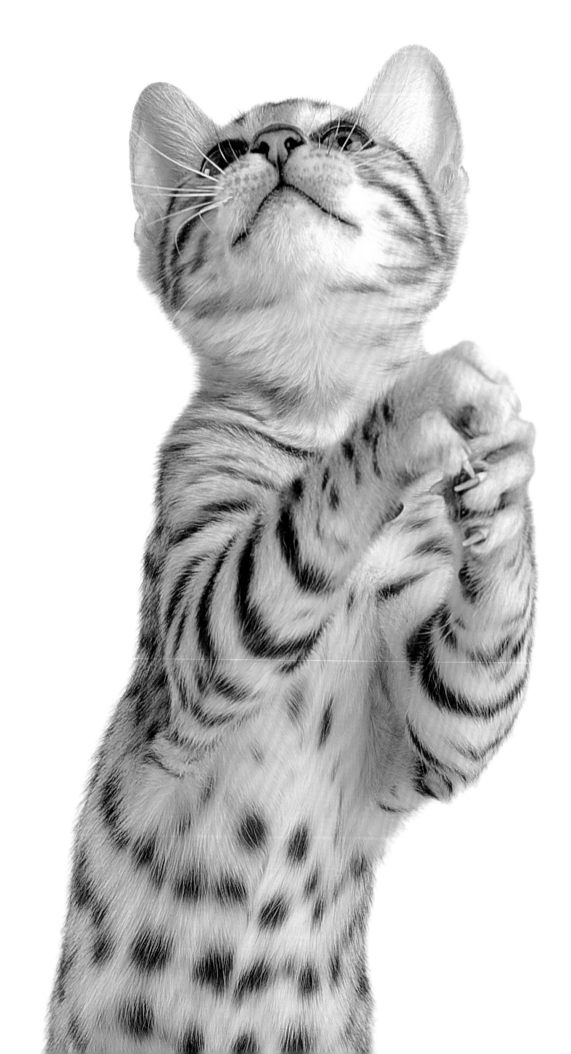

ABOVE: DIVA, 12 WEEKS OPPOSITE: HOBBES, 9 WEEKS

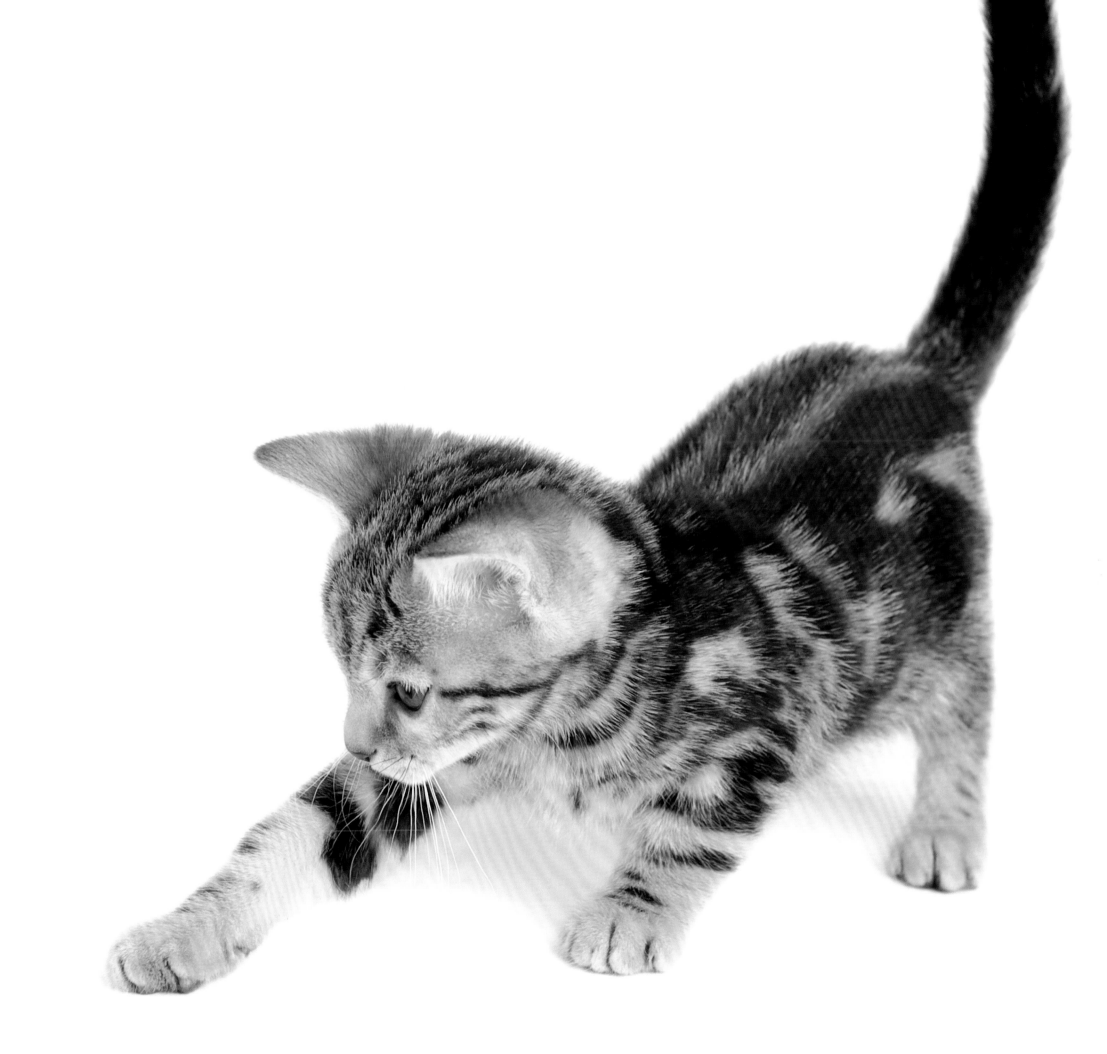

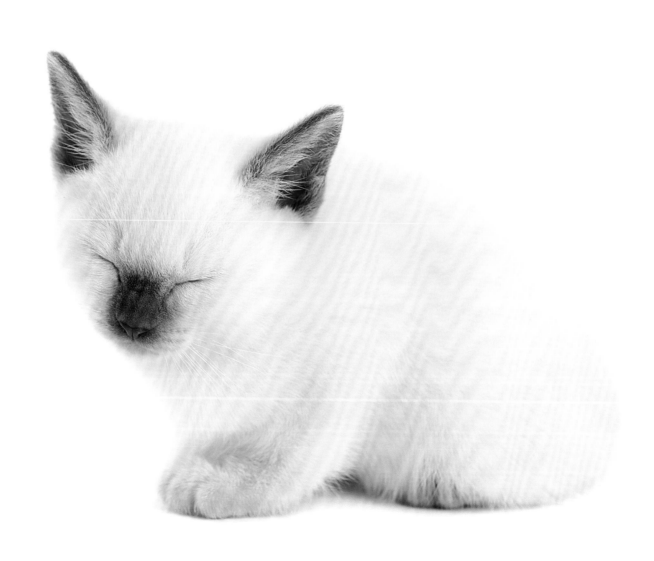

cosmo | Tonkinese: 6 weeks, 1 lb

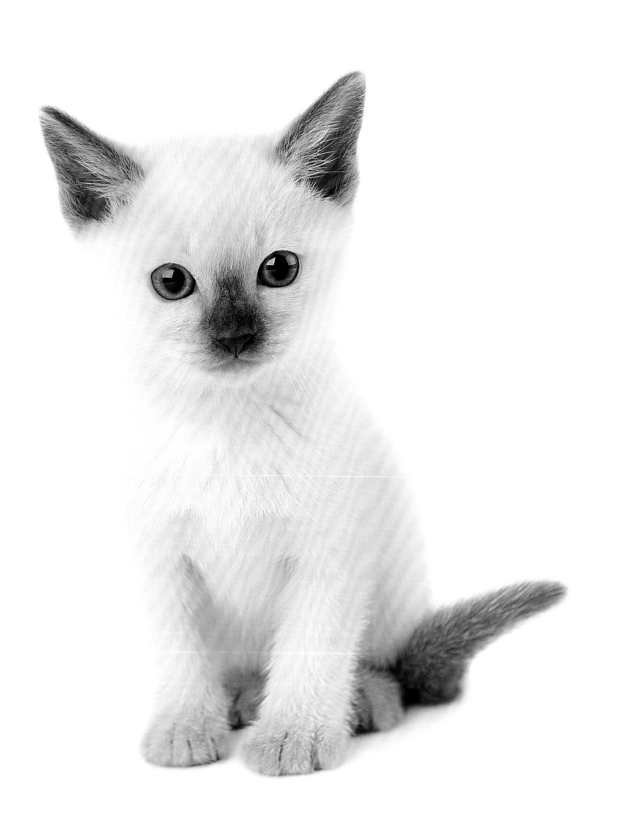

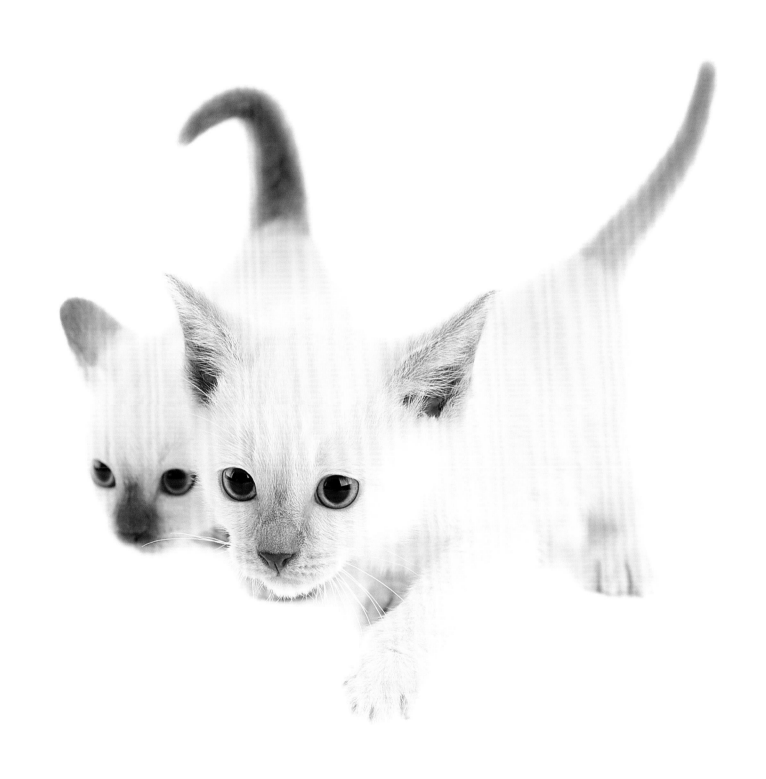

OPPOSITE: COSMO ABOVE: COSMO & ZOE

bella | Exotic Longhair: 9 weeks, 2.5 lbs

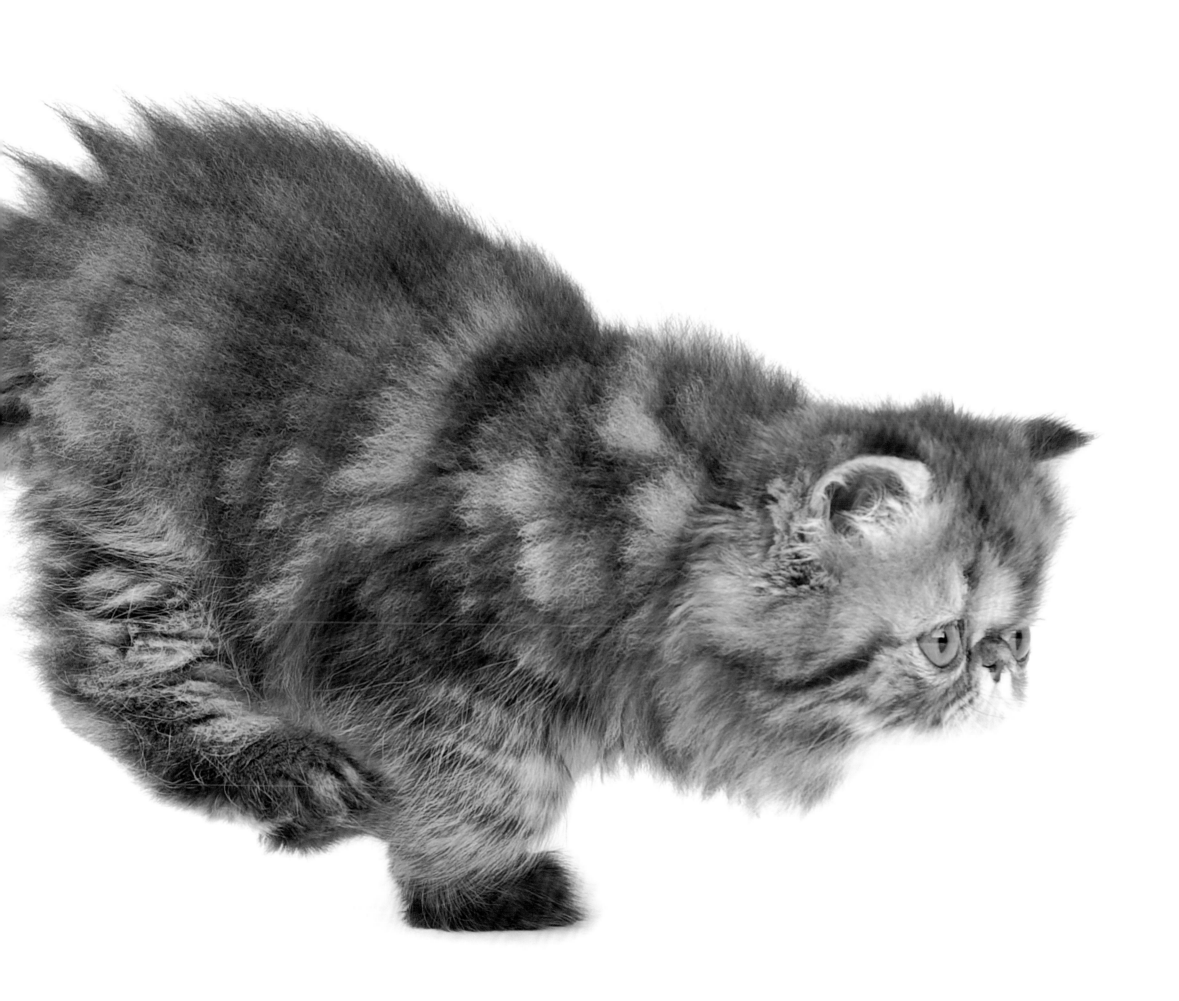

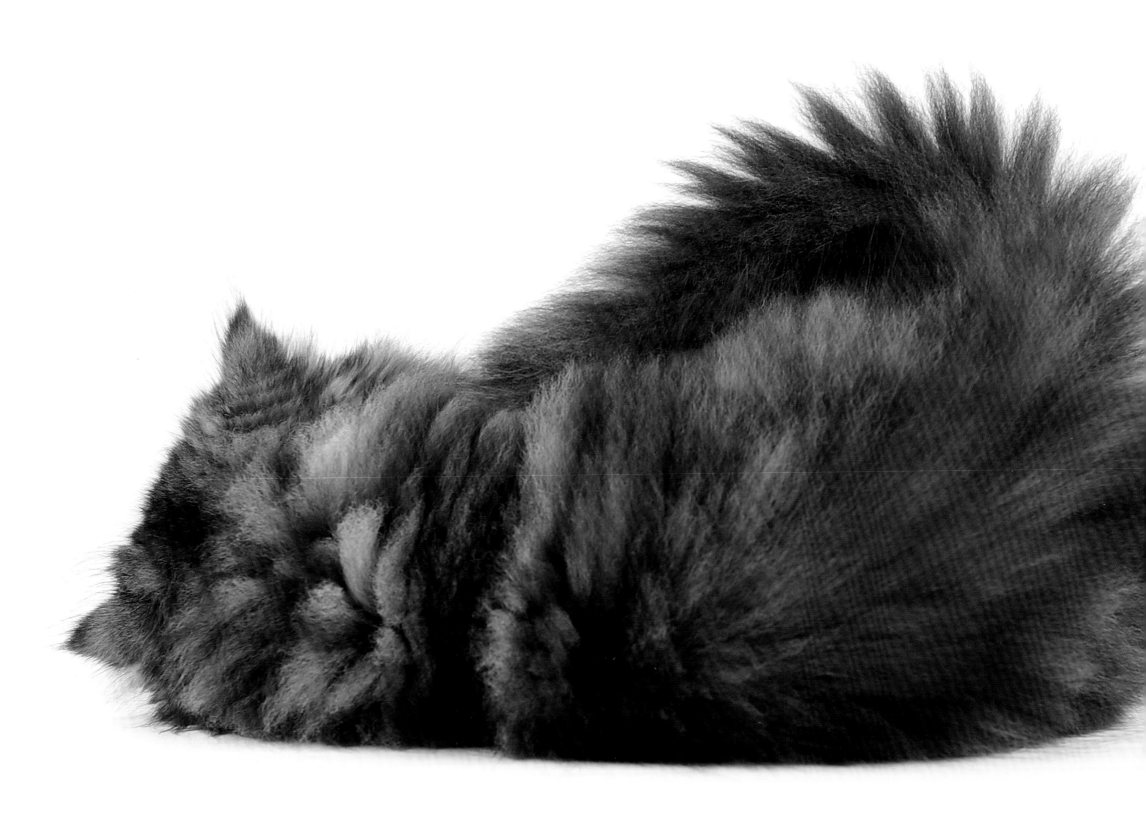

ABOVE & OPPOSITE: BELLA

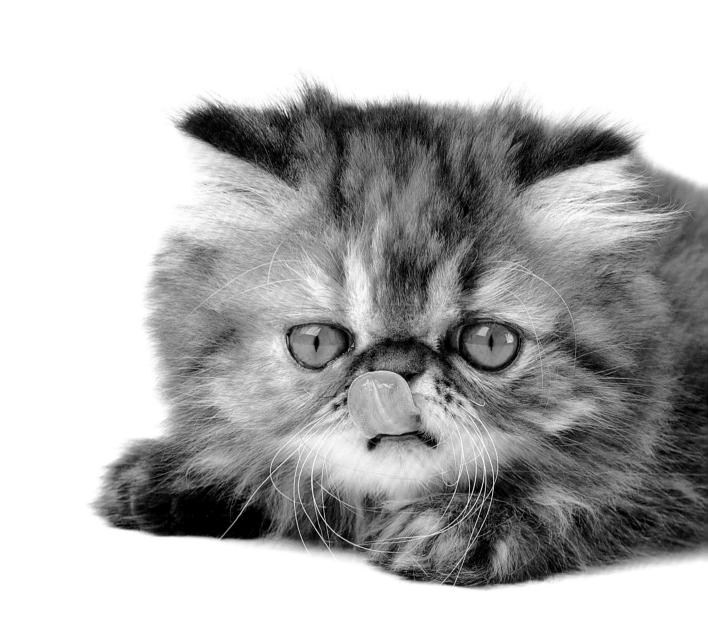

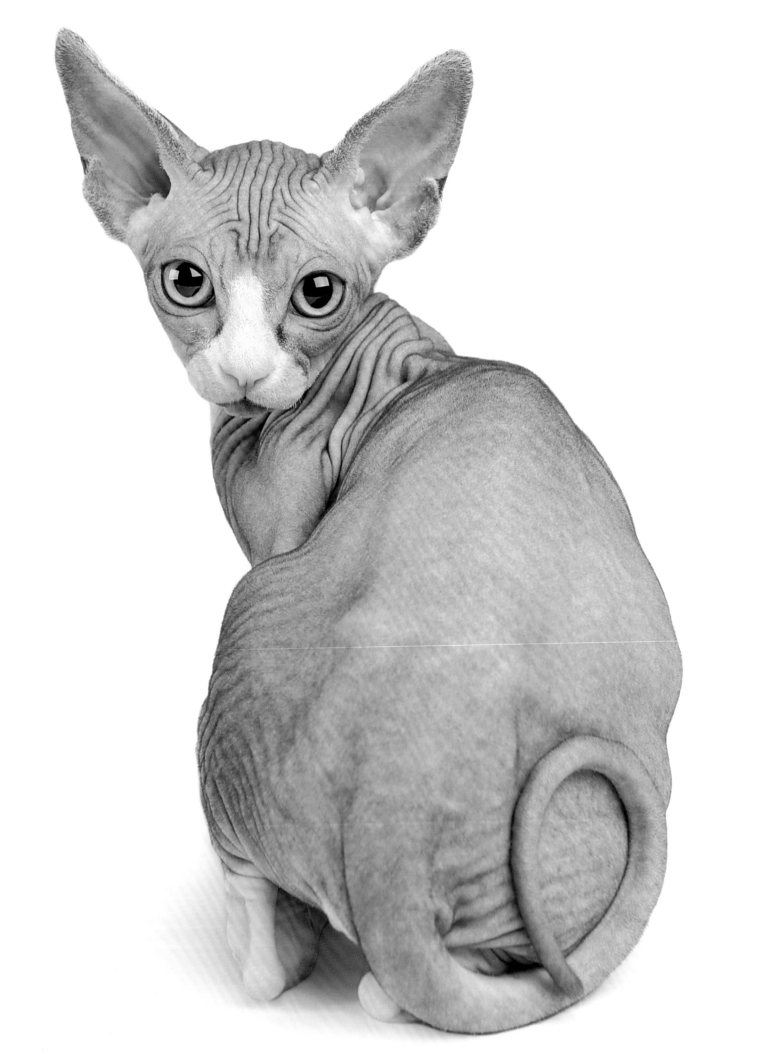

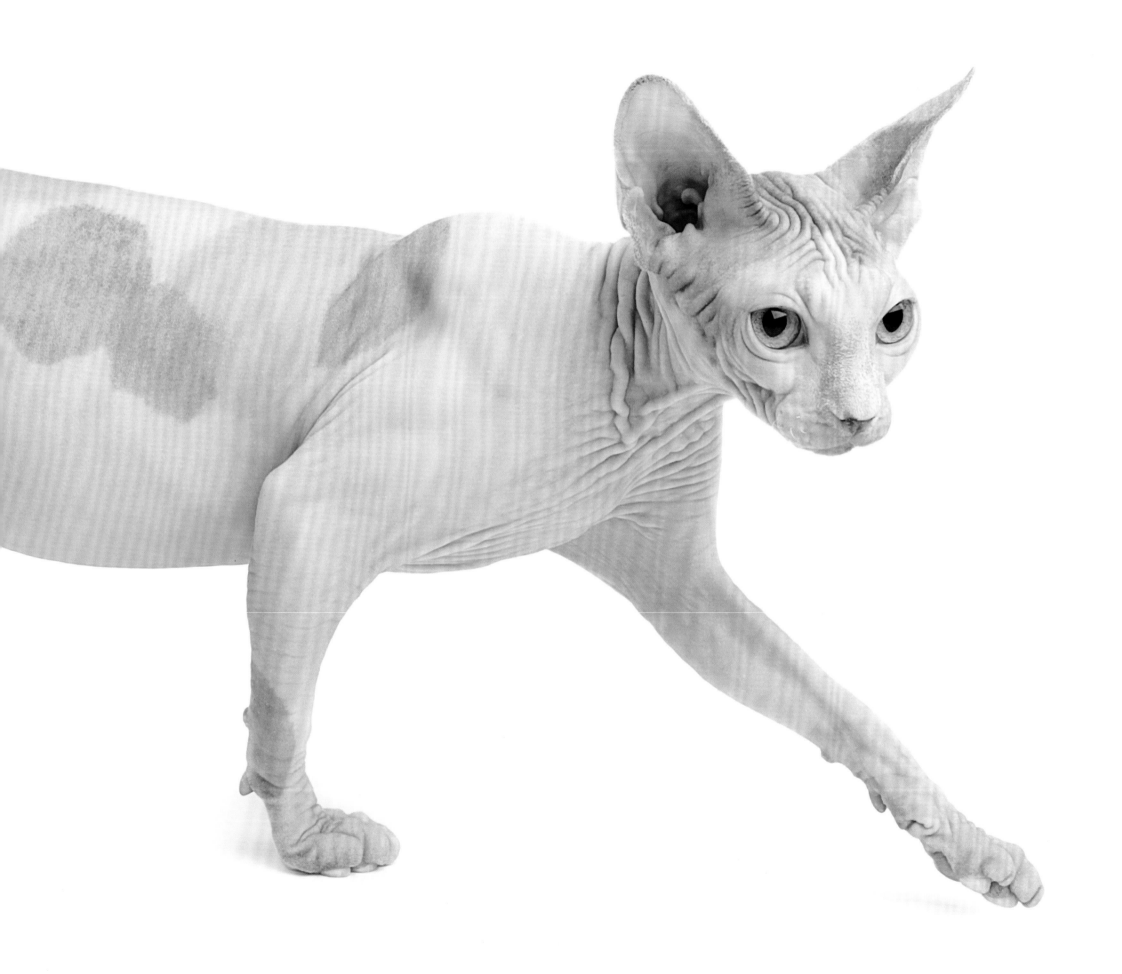

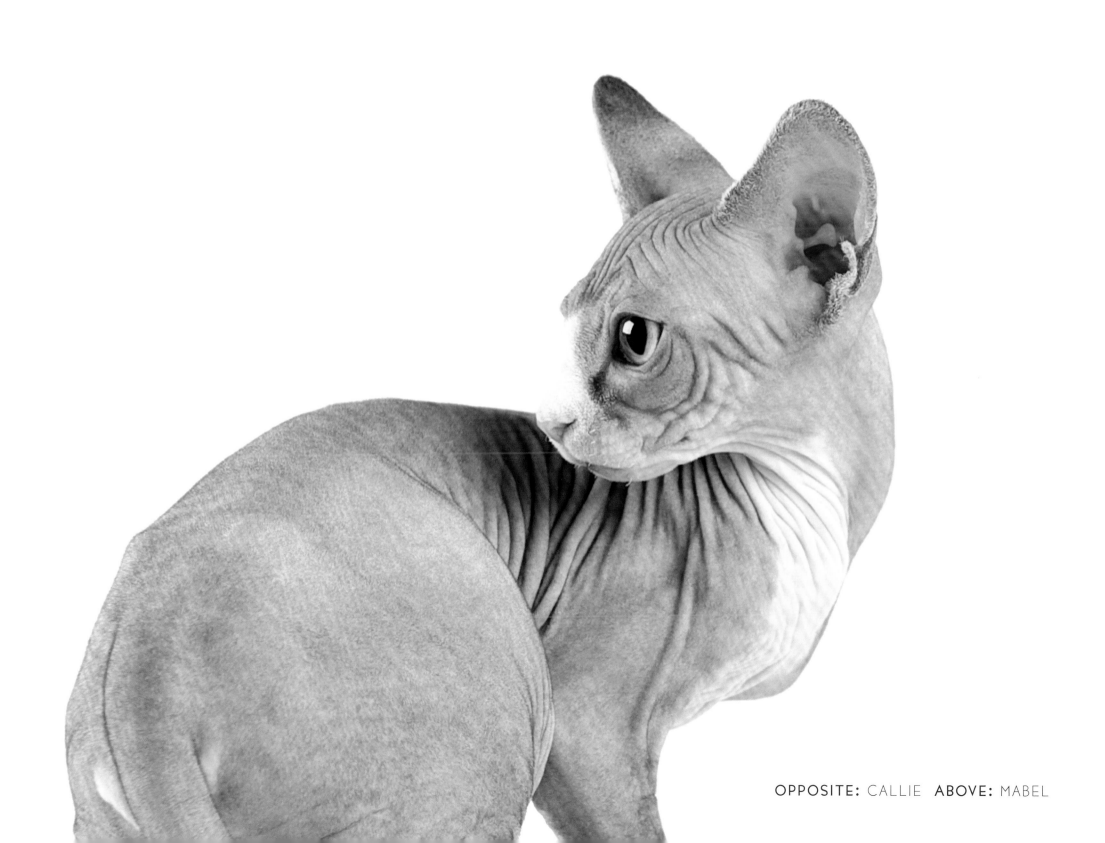

OPPOSITE: CALLIE ABOVE: MABEL

june | Black Mix: 9 weeks, 2 lbs

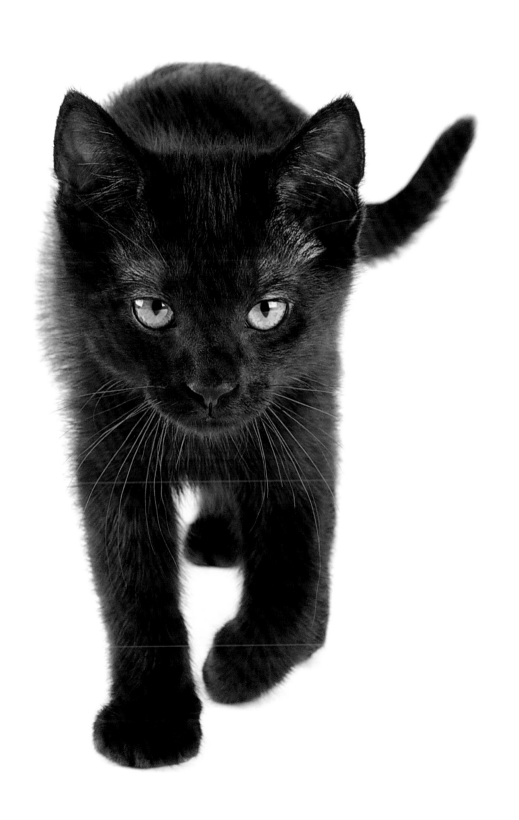

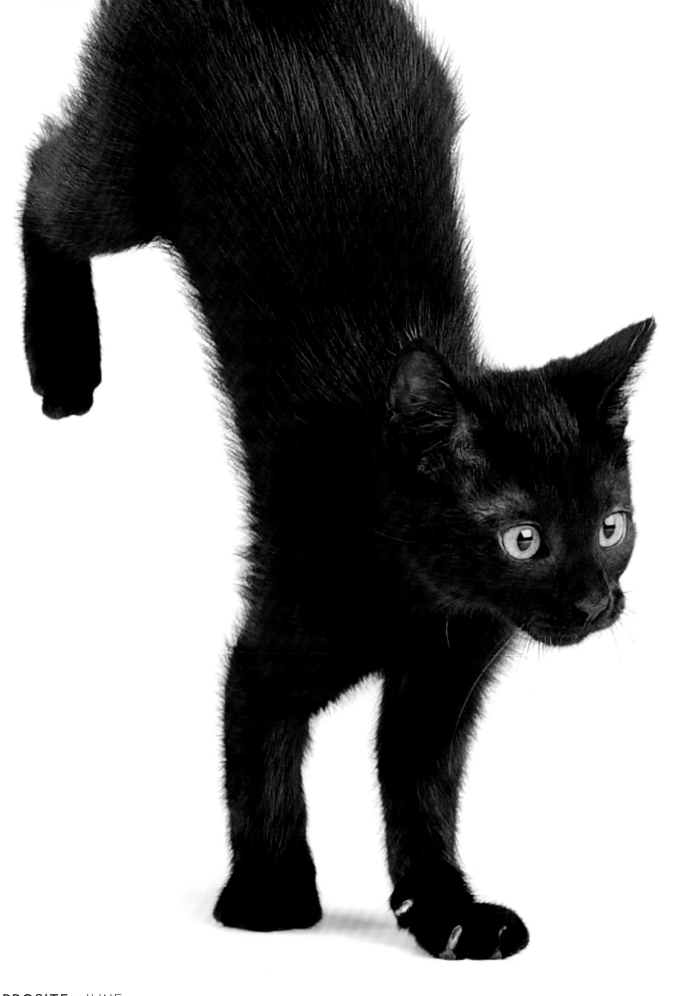

ABOVE: JOHNNY OPPOSITE: JUNE

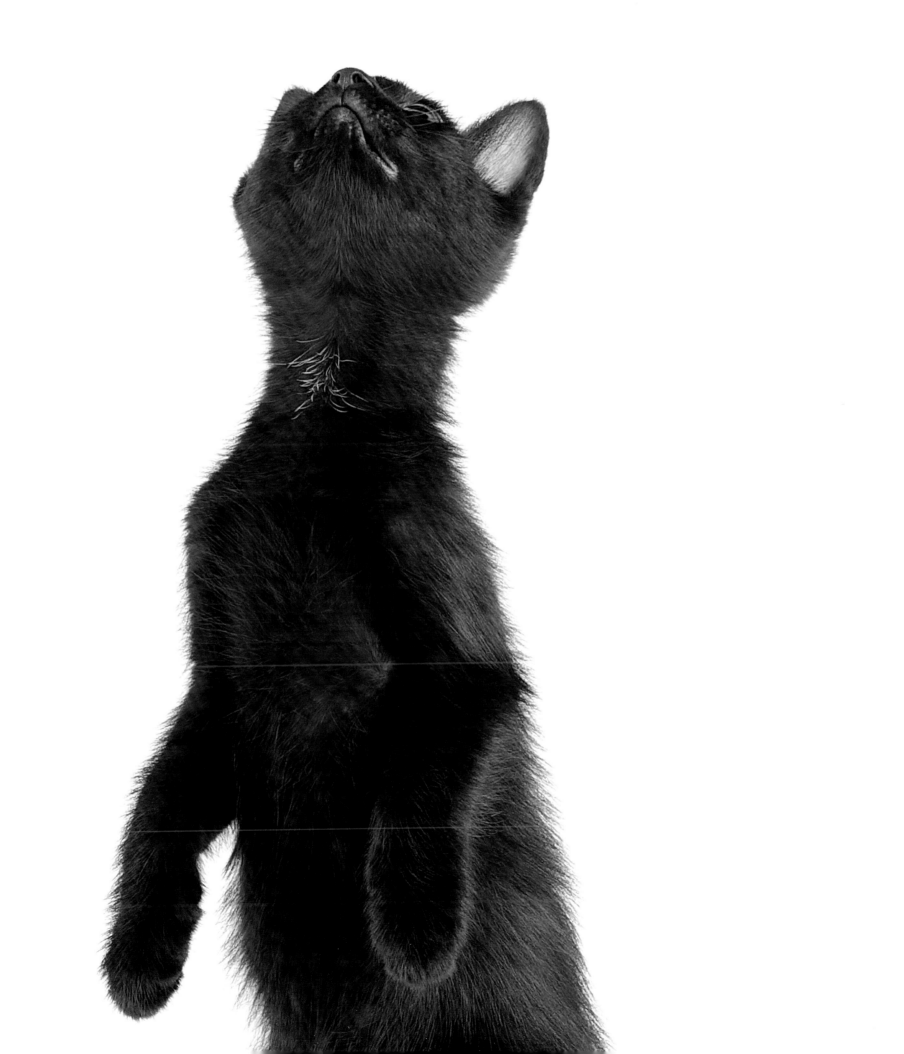

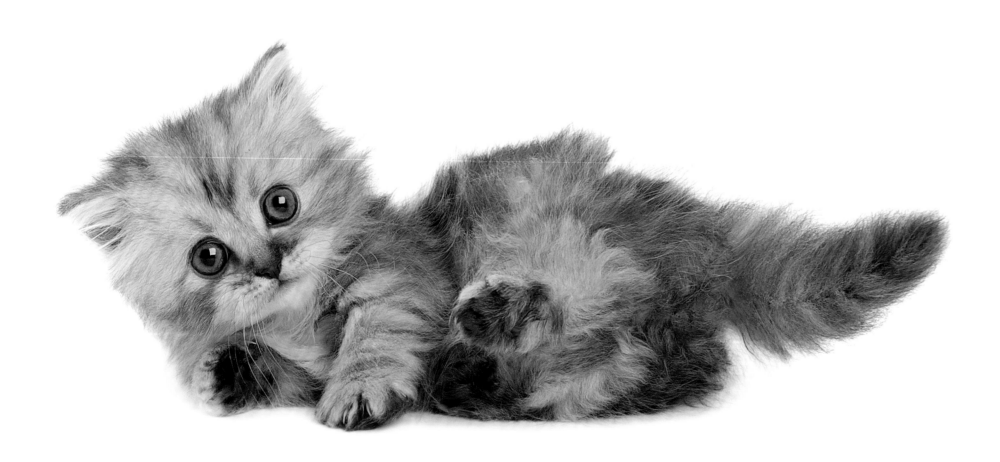

tillie | Napoleon: 6 weeks, 0.75 lb

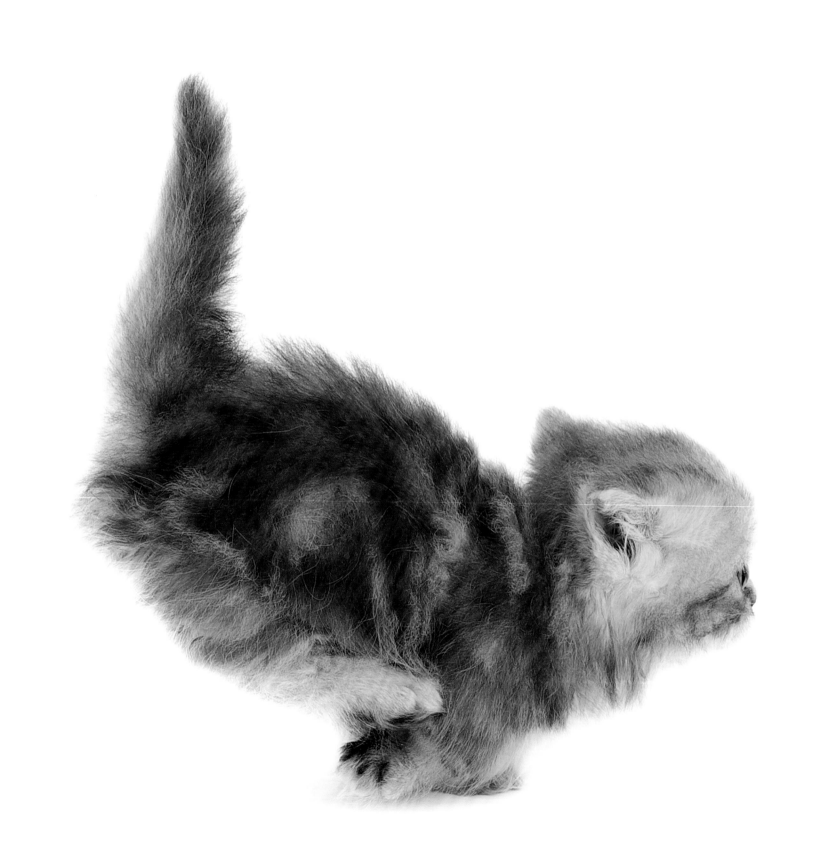

OPPOSITE: TILLIE ABOVE: EMMETT & TILLIE

atomic dude | Ocicat: 7 weeks, 2 lbs

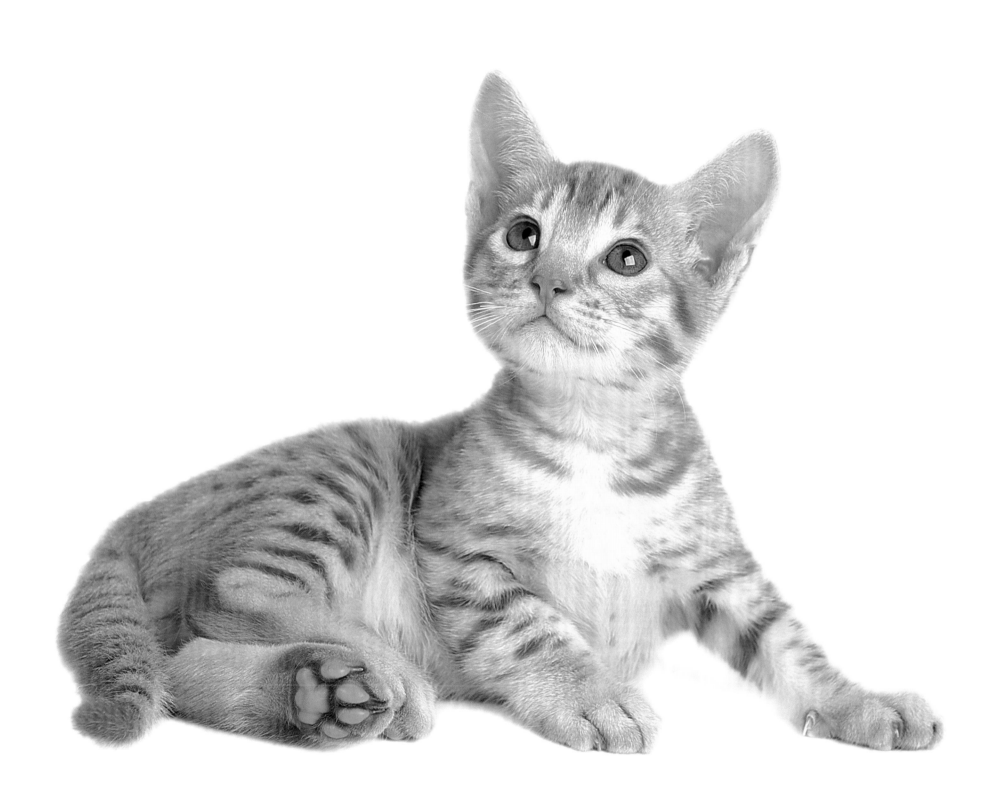

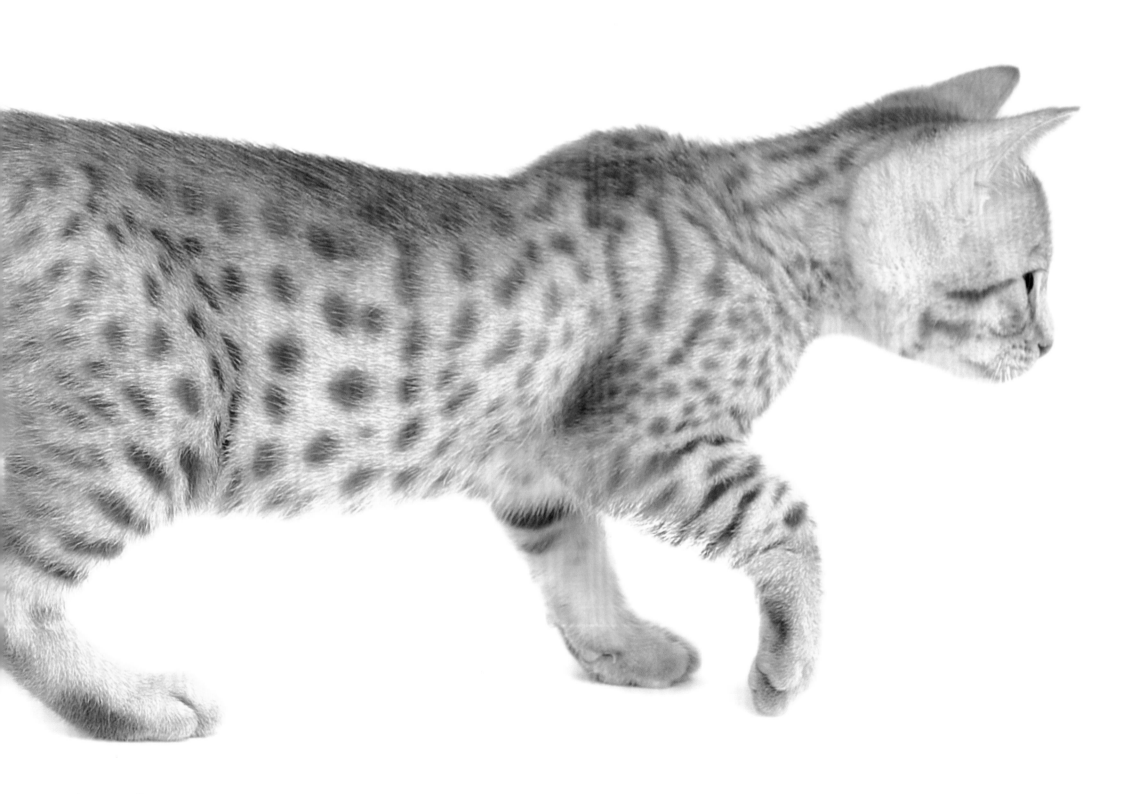

ABOVE & OPPOSITE: ATOMIC DUDE

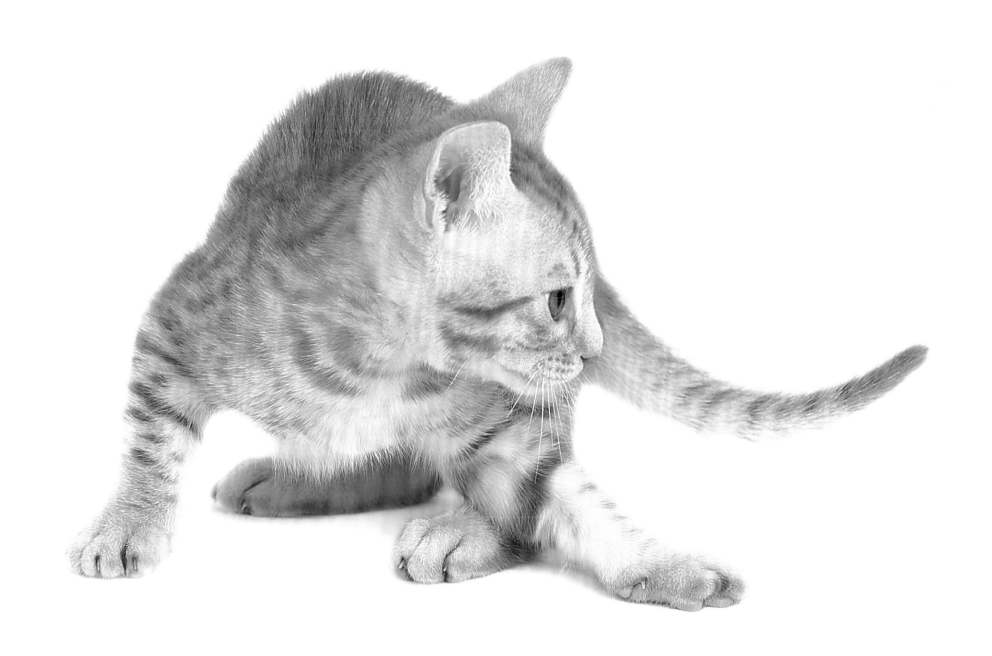

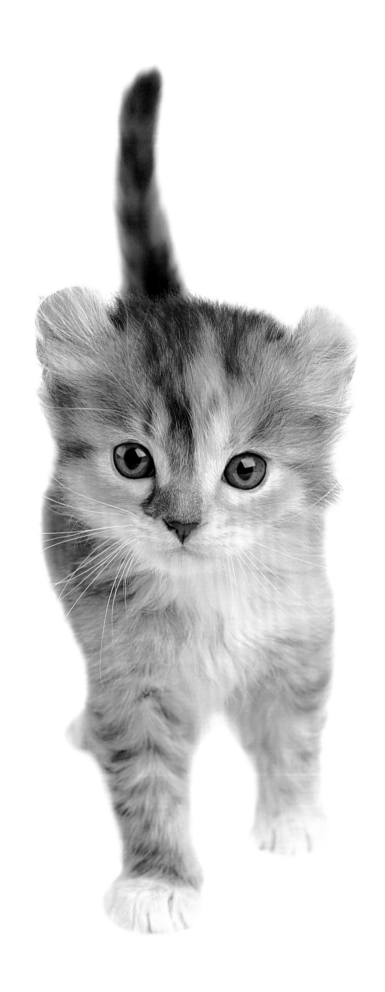

dixieland | American Curl: 5 weeks, 0.75 lb

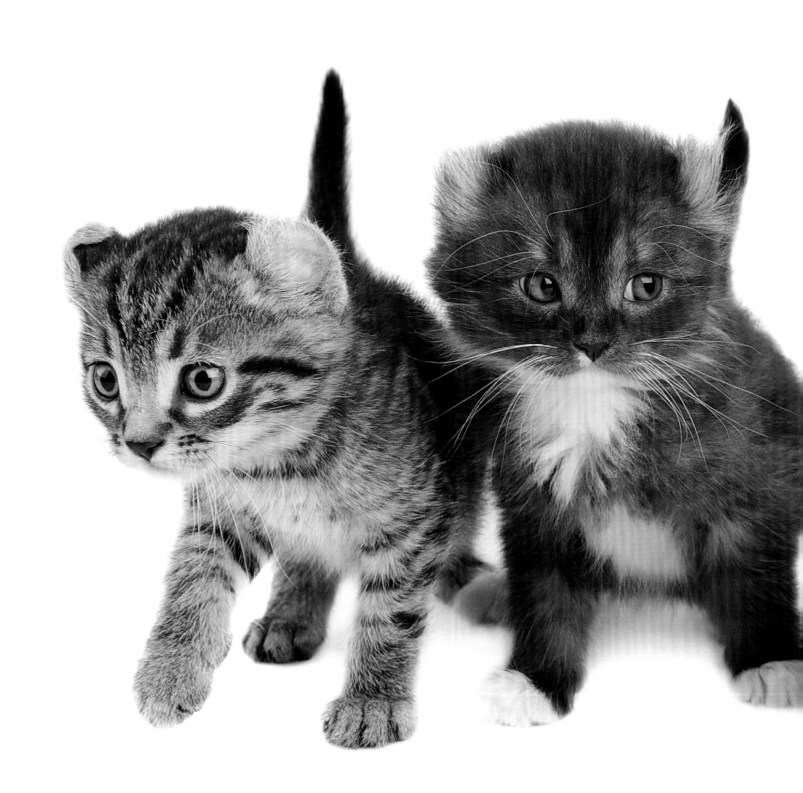

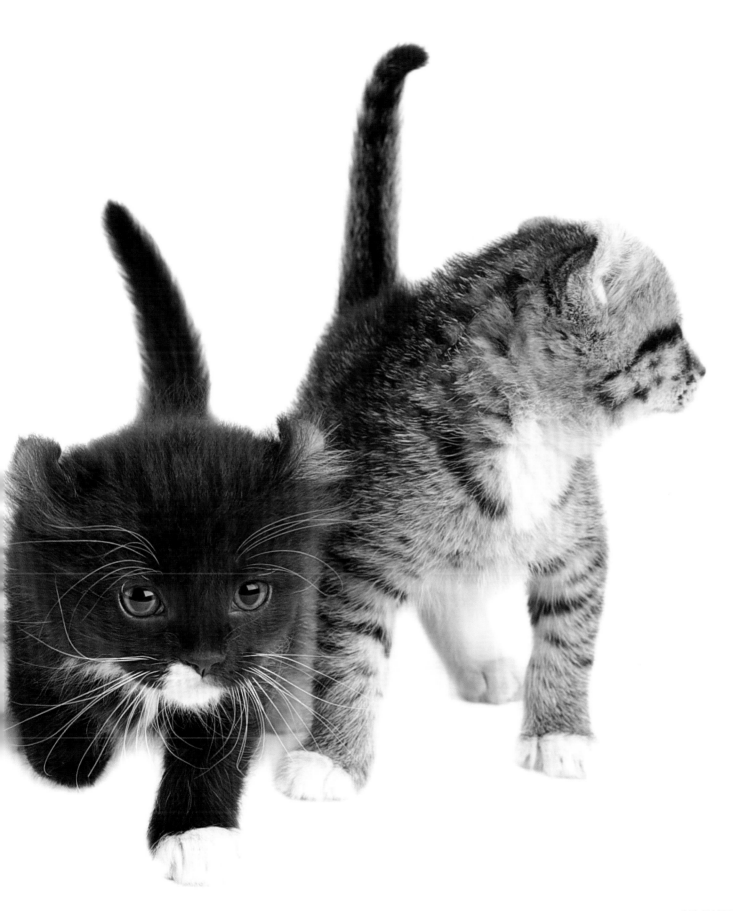

ABOVE: HARPER TIARA, SILLY, GUMBY & PLATINUM SKY

smokey | Selkirk Rex: 12 weeks, 4 lbs

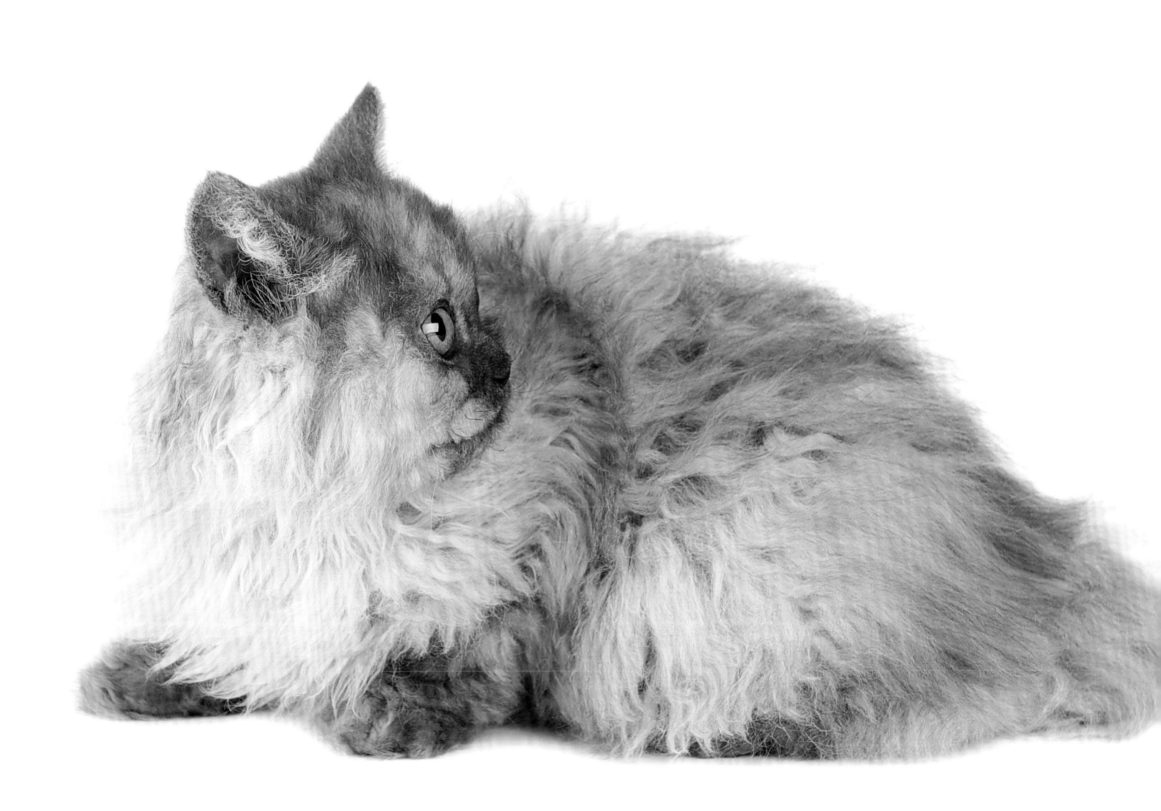

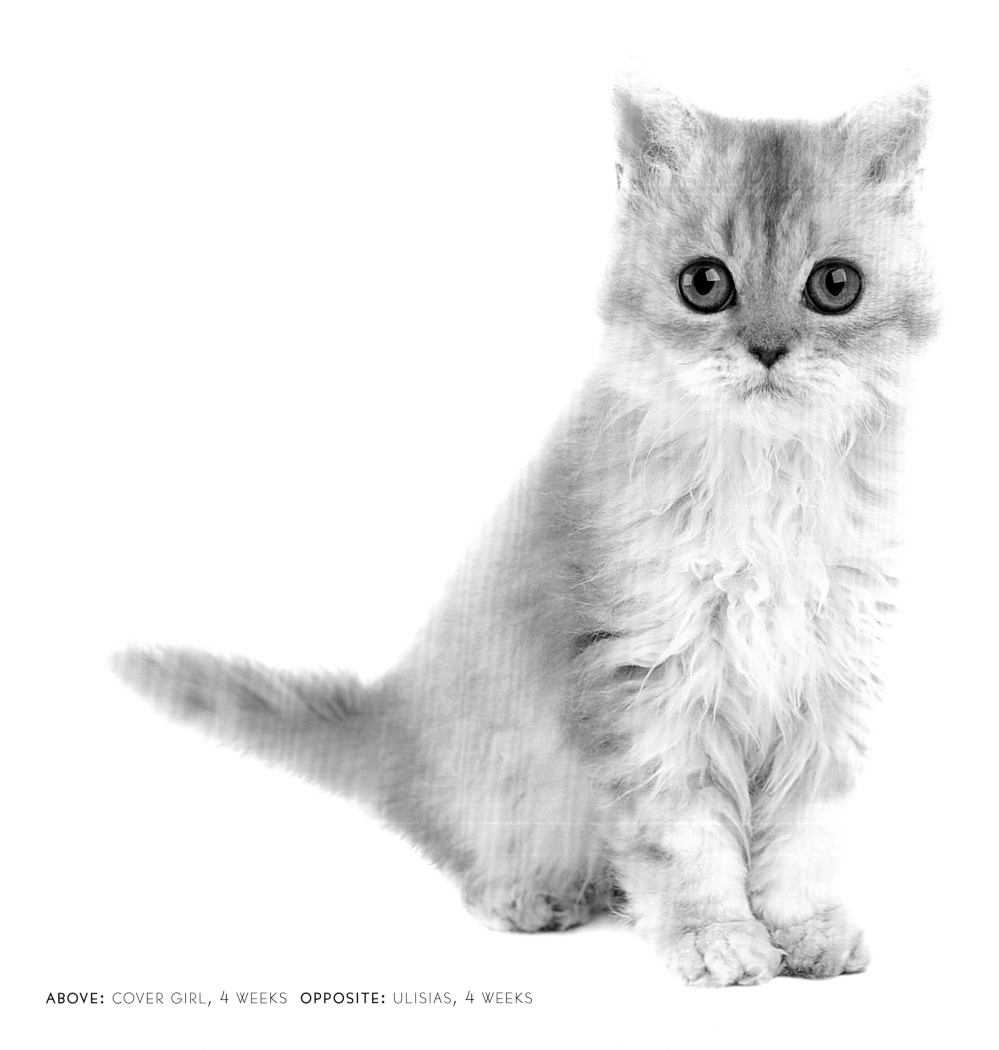

ABOVE: COVER GIRL, 4 WEEKS OPPOSITE: ULISIAS, 4 WEEKS

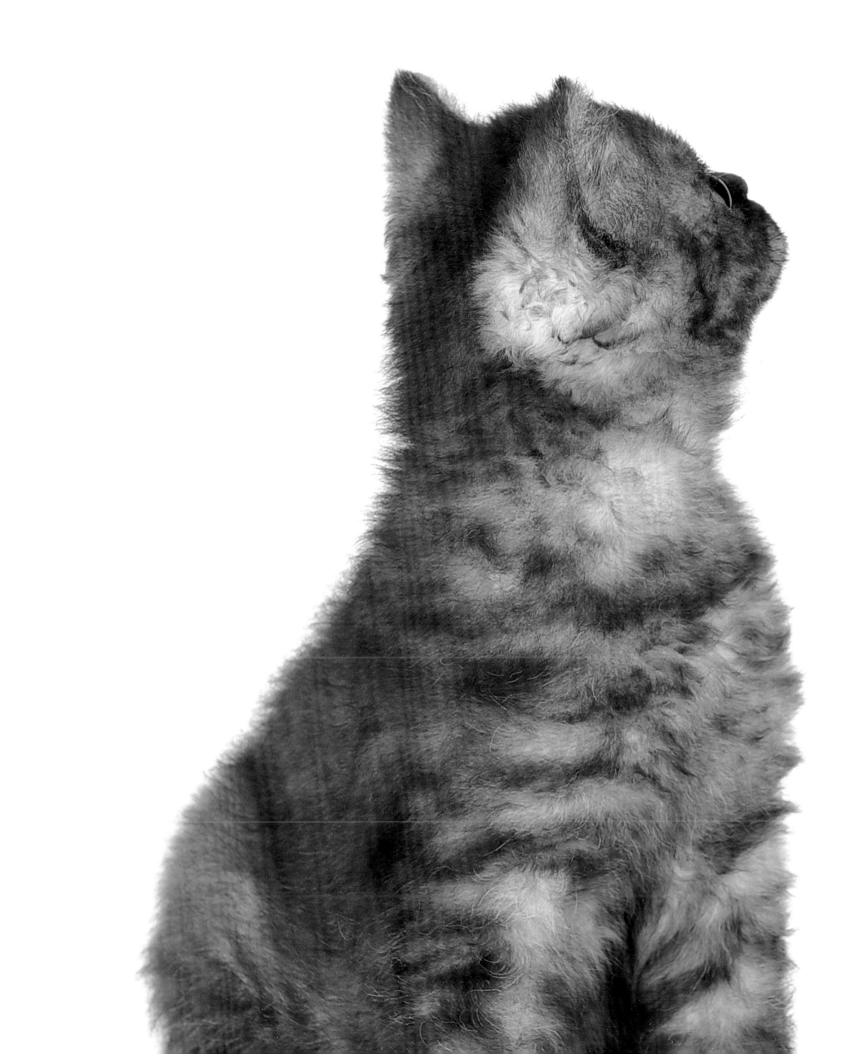

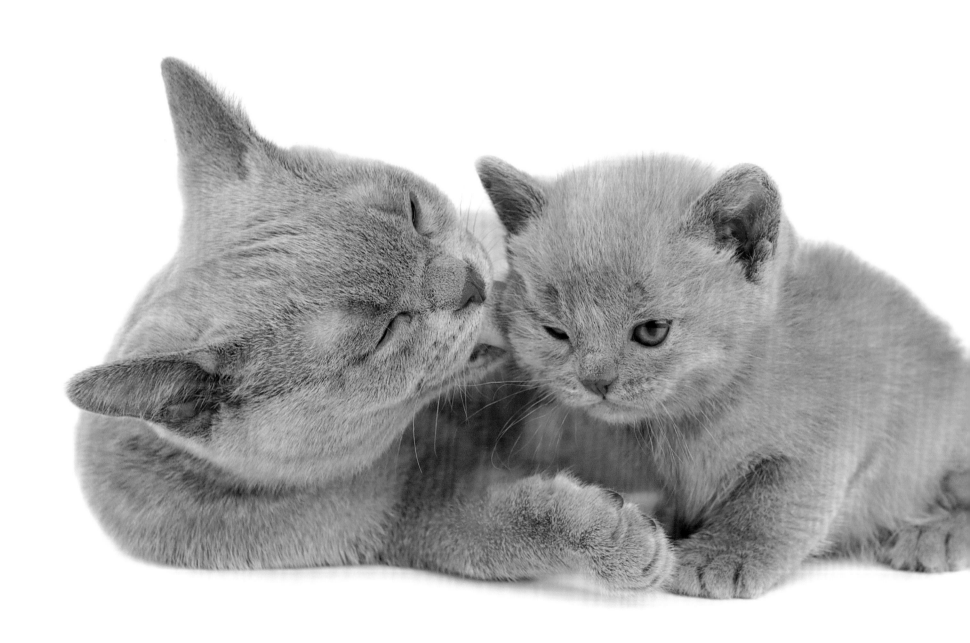

roland & delicious | Burmese: 12 weeks, 3 lbs / 6 weeks, 1 lb

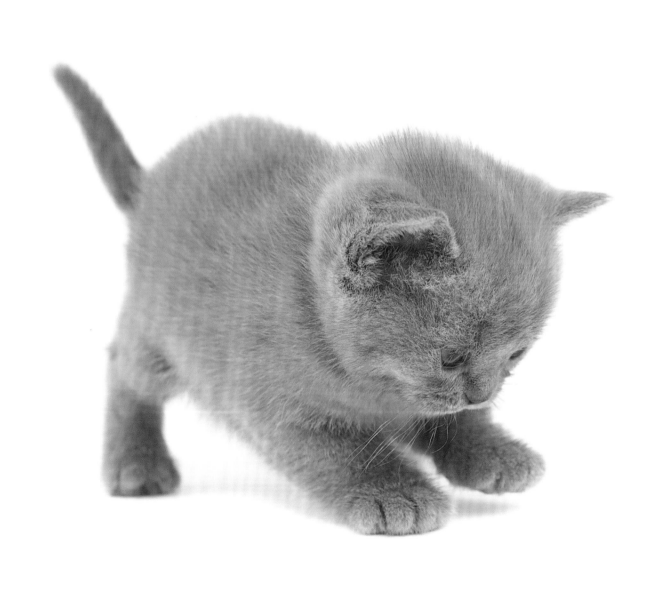

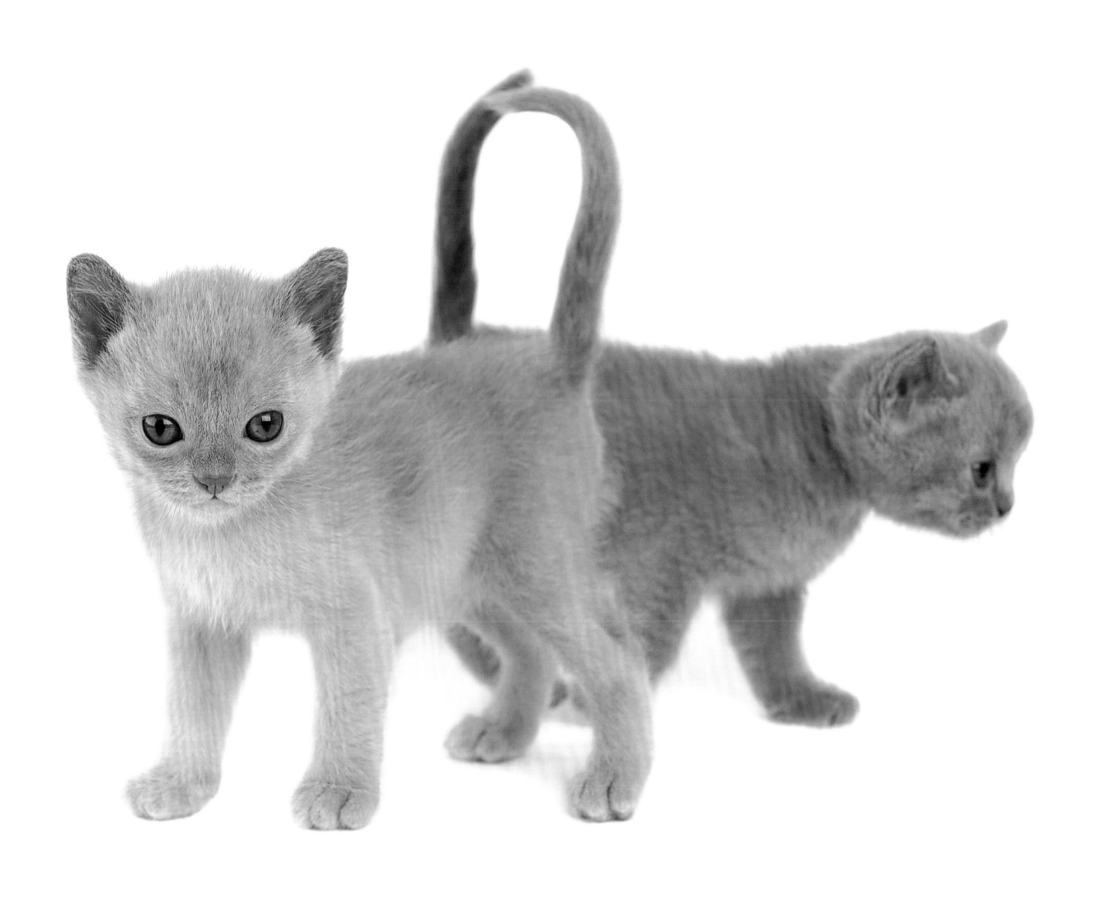

OPPOSITE: DELICIOUS ABOVE: BROTHER & DELICIOUS

petal | Siberian: 9 weeks, 2.5 lbs

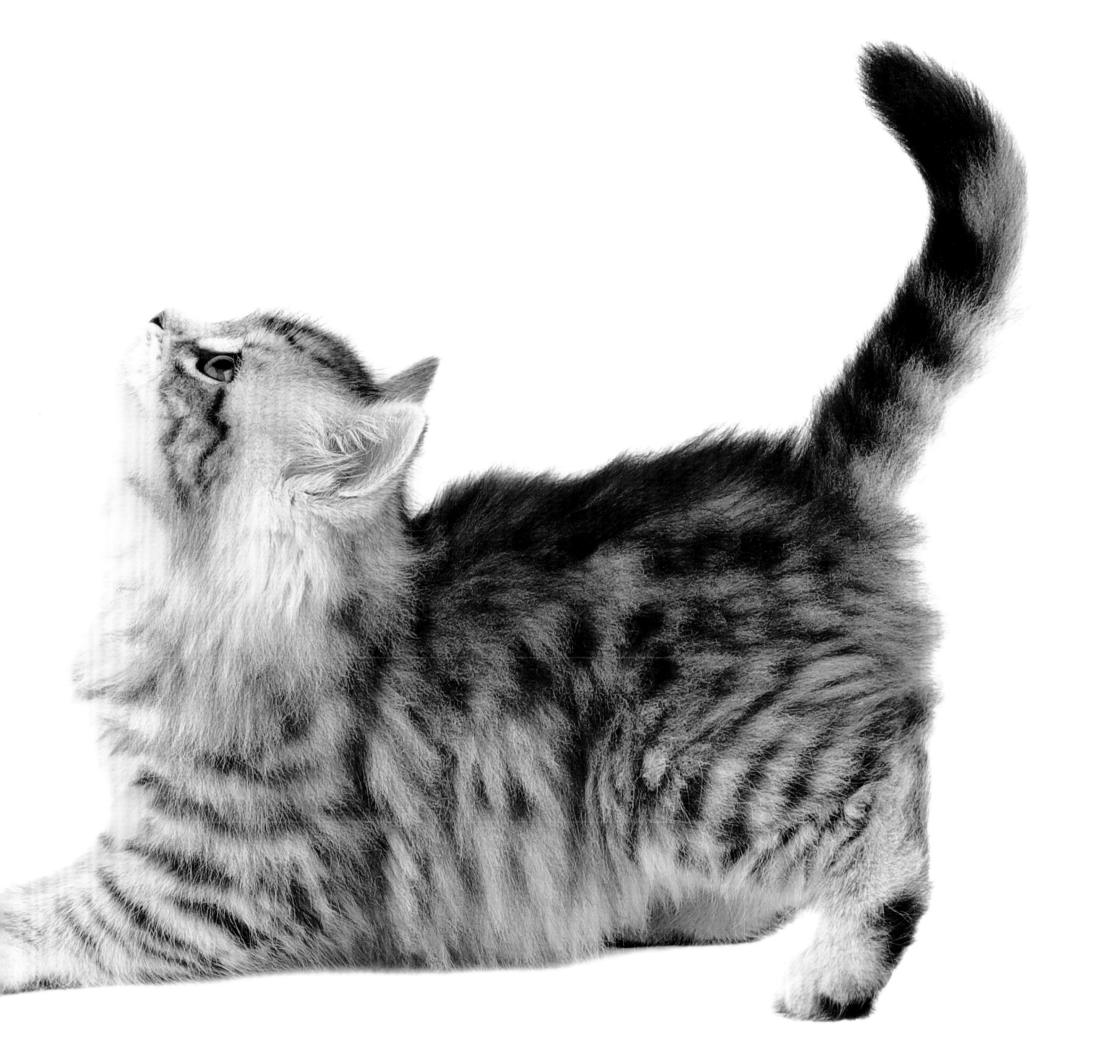

ABOVE: TIMBER OPPOSITE: PETAL, TIMBER & SKY

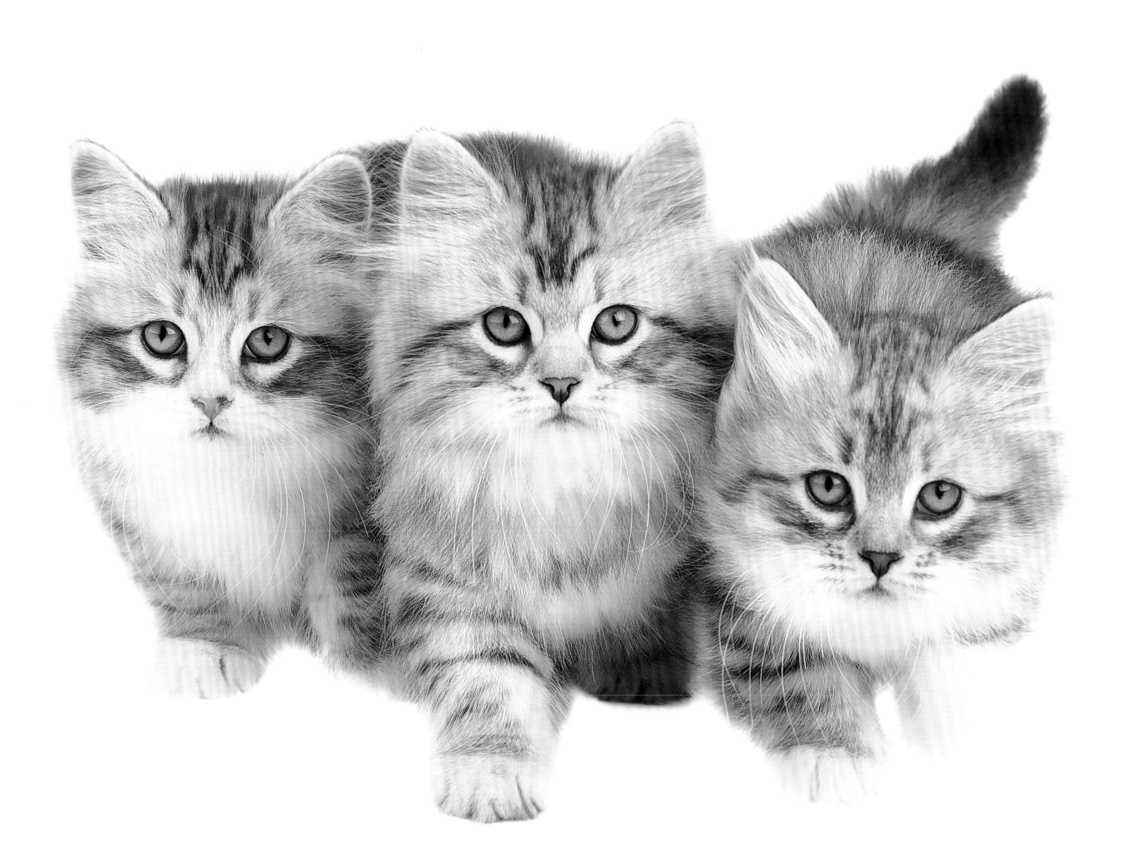

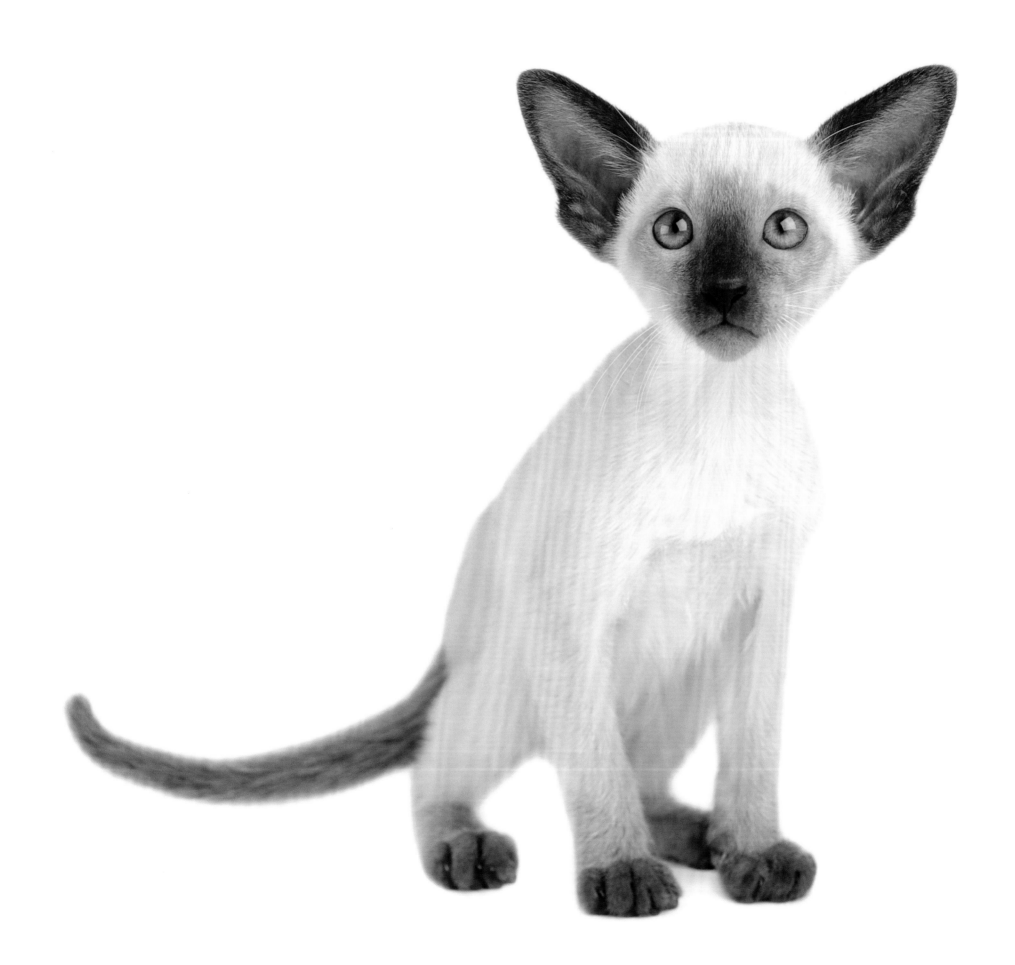

sonnet | Siamese: 7 weeks, 1.9 lbs

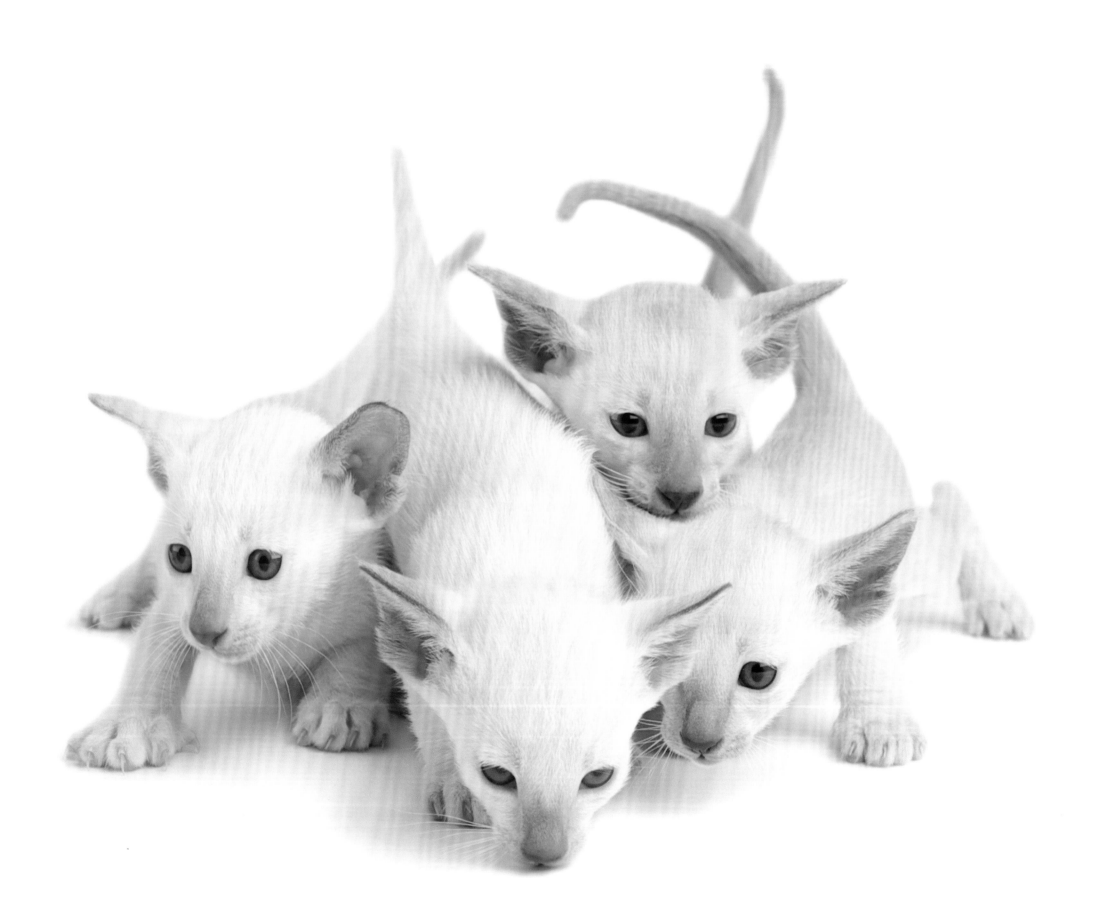

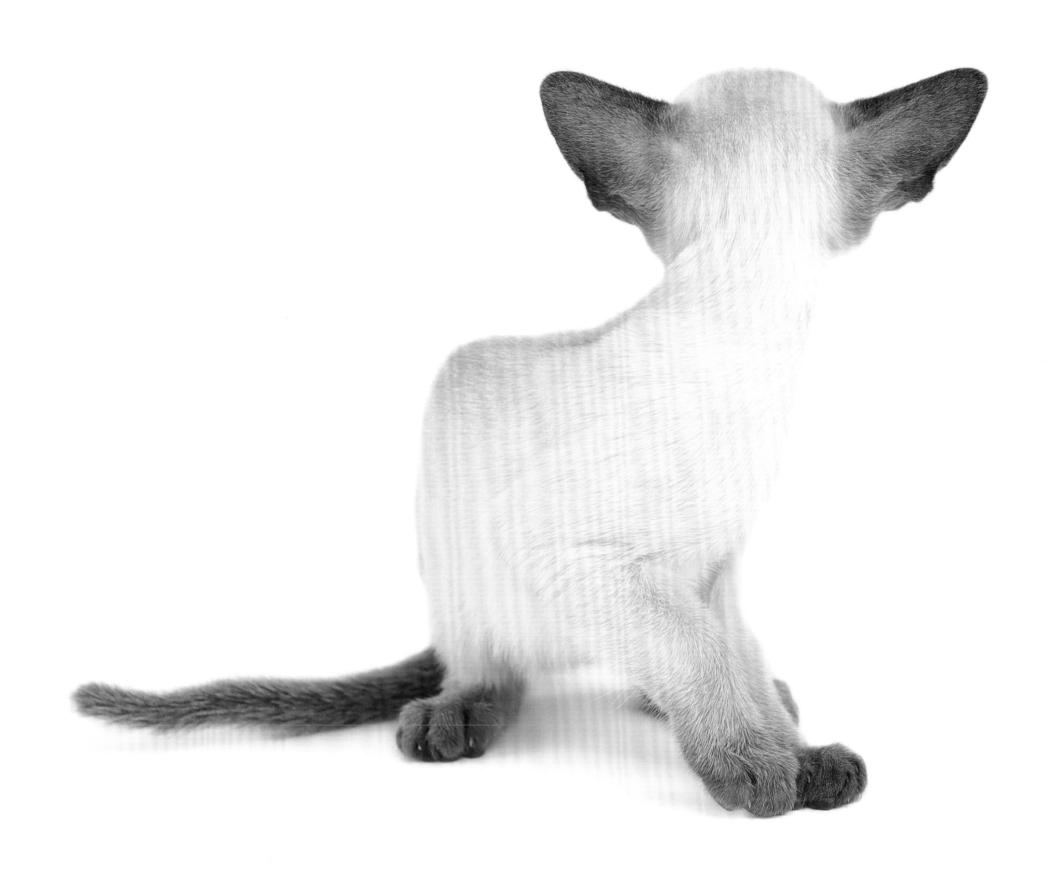

OPPOSITE: TWIST, CACHET, RHYME & MELODY, 4 WEEKS ABOVE: MEWSIC, 7 WEEKS

gizmo | Tortoiseshell Mix: 7 weeks, 2 lbs

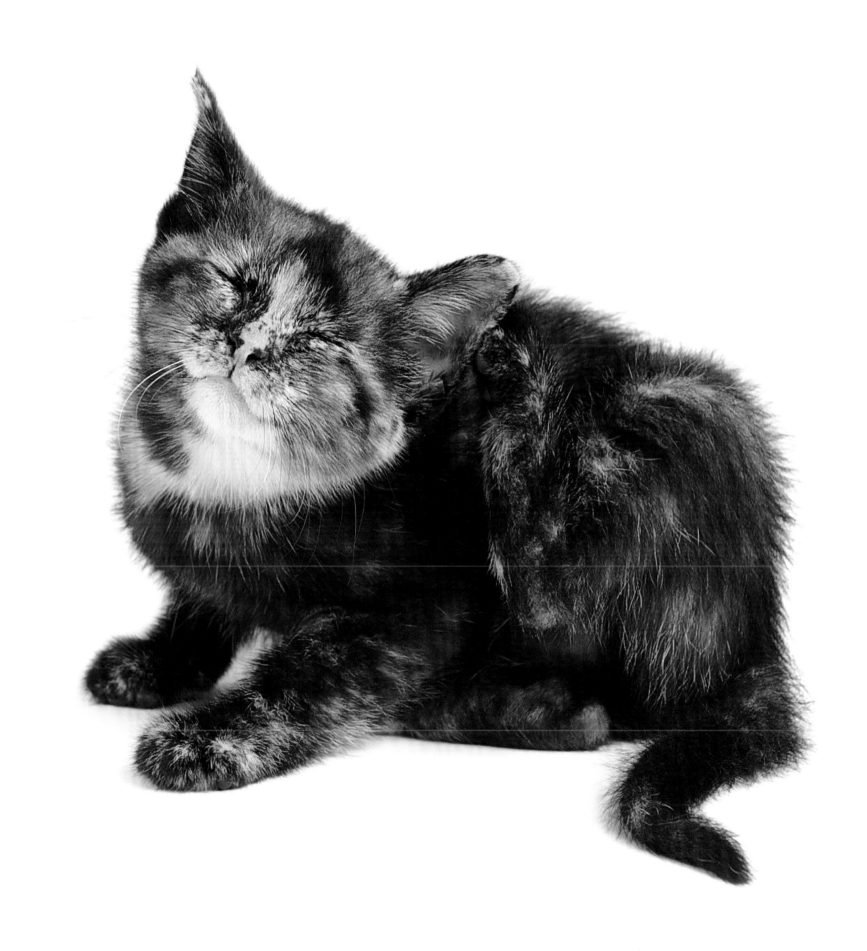

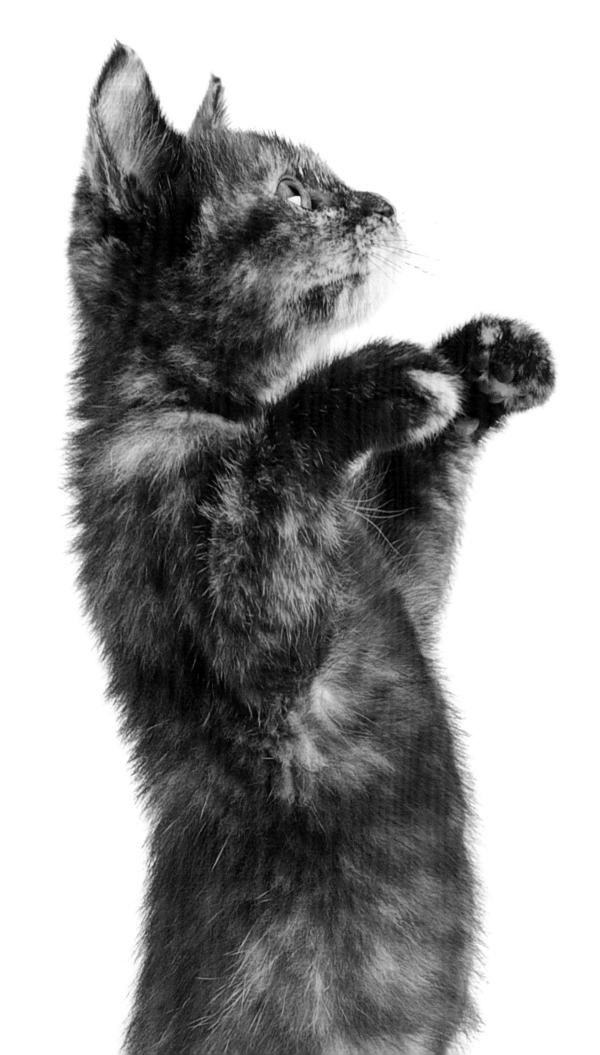

ABOVE: GIZMO OPPOSITE: GIDGET

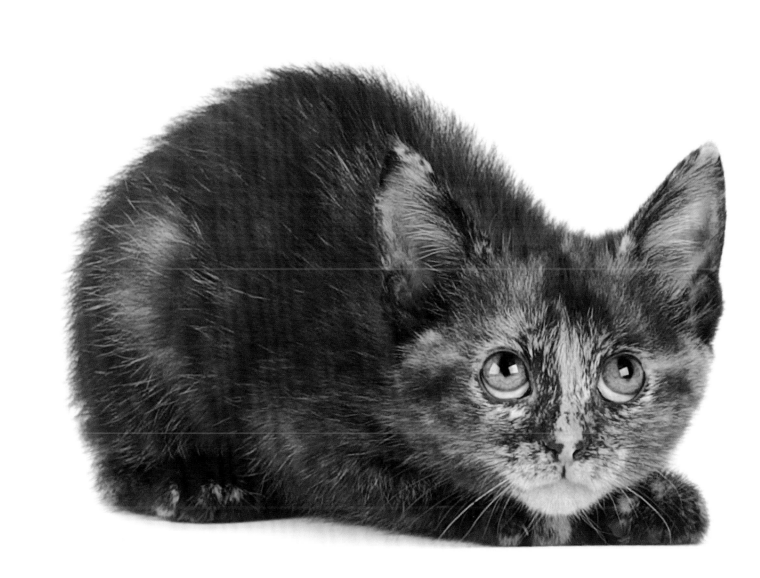

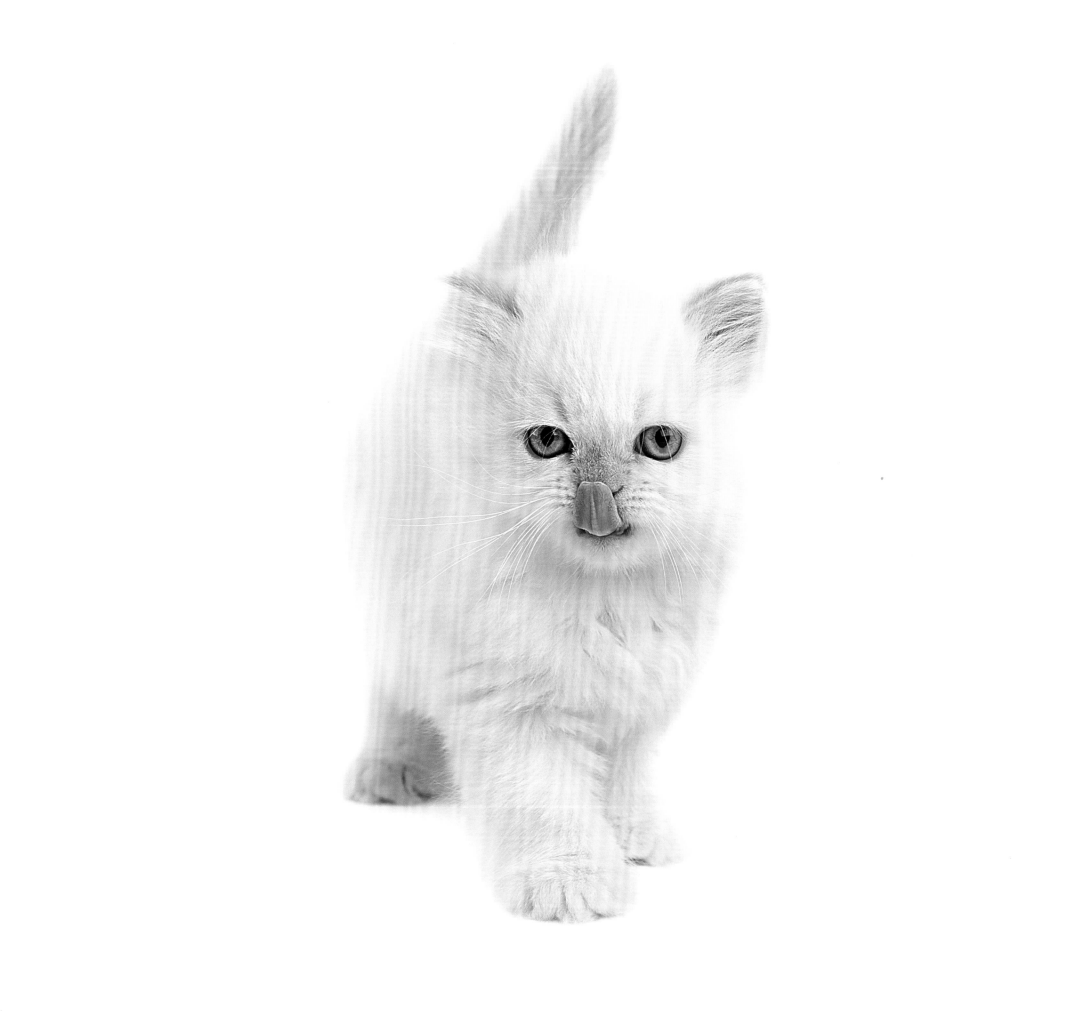

roo | Himalayan Persian: 7 weeks, 1.5 lbs

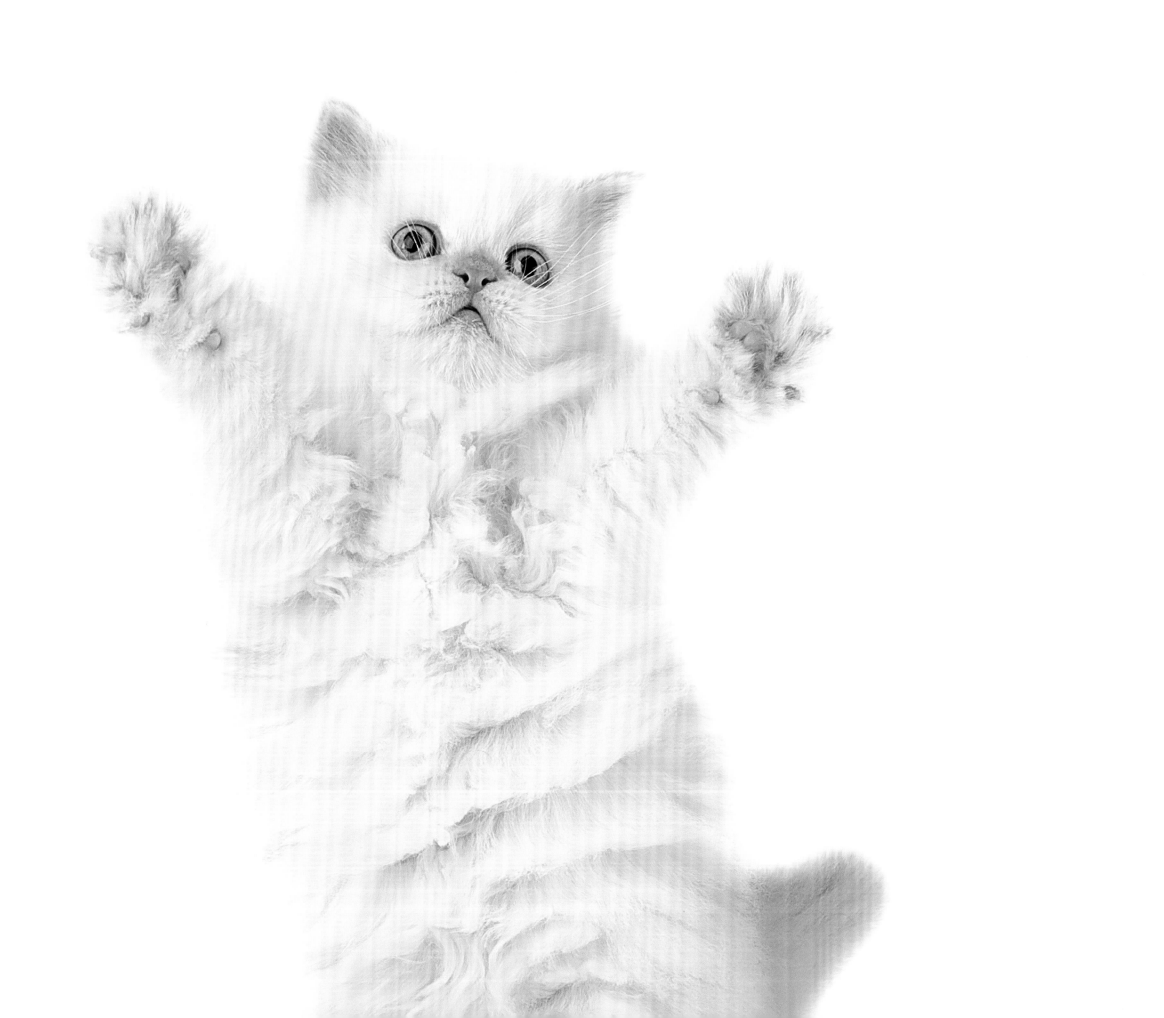

petunia | American Shorthair: 9 weeks, 2 lbs

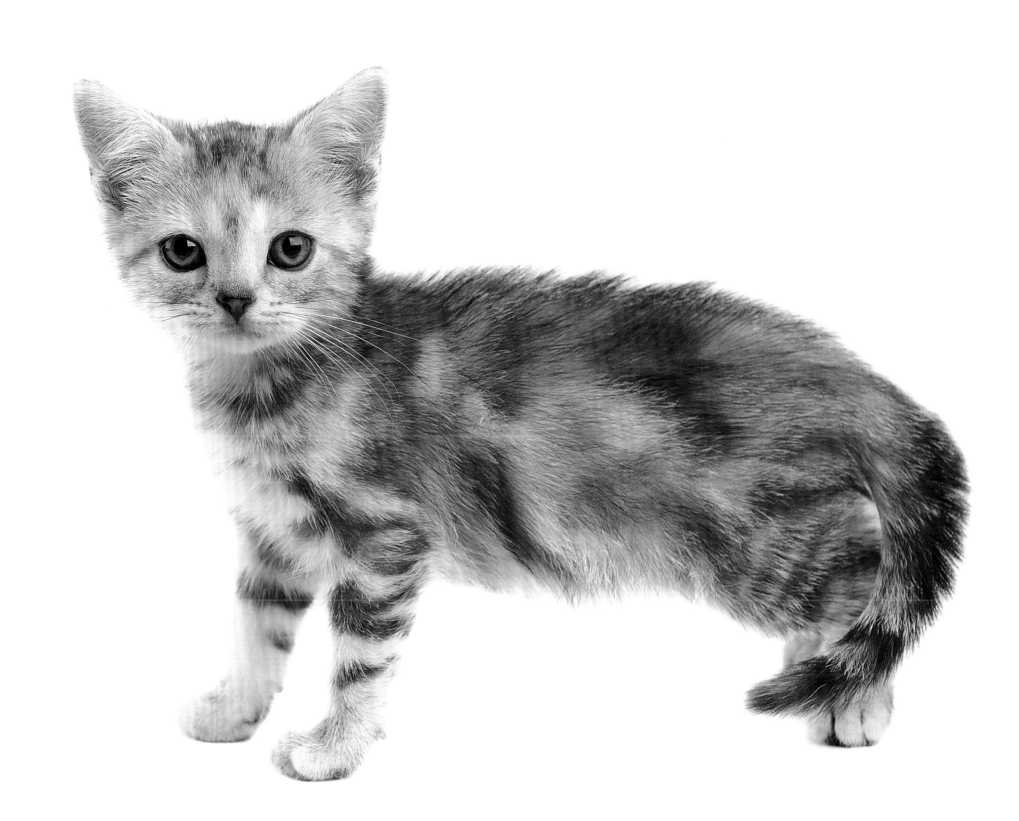

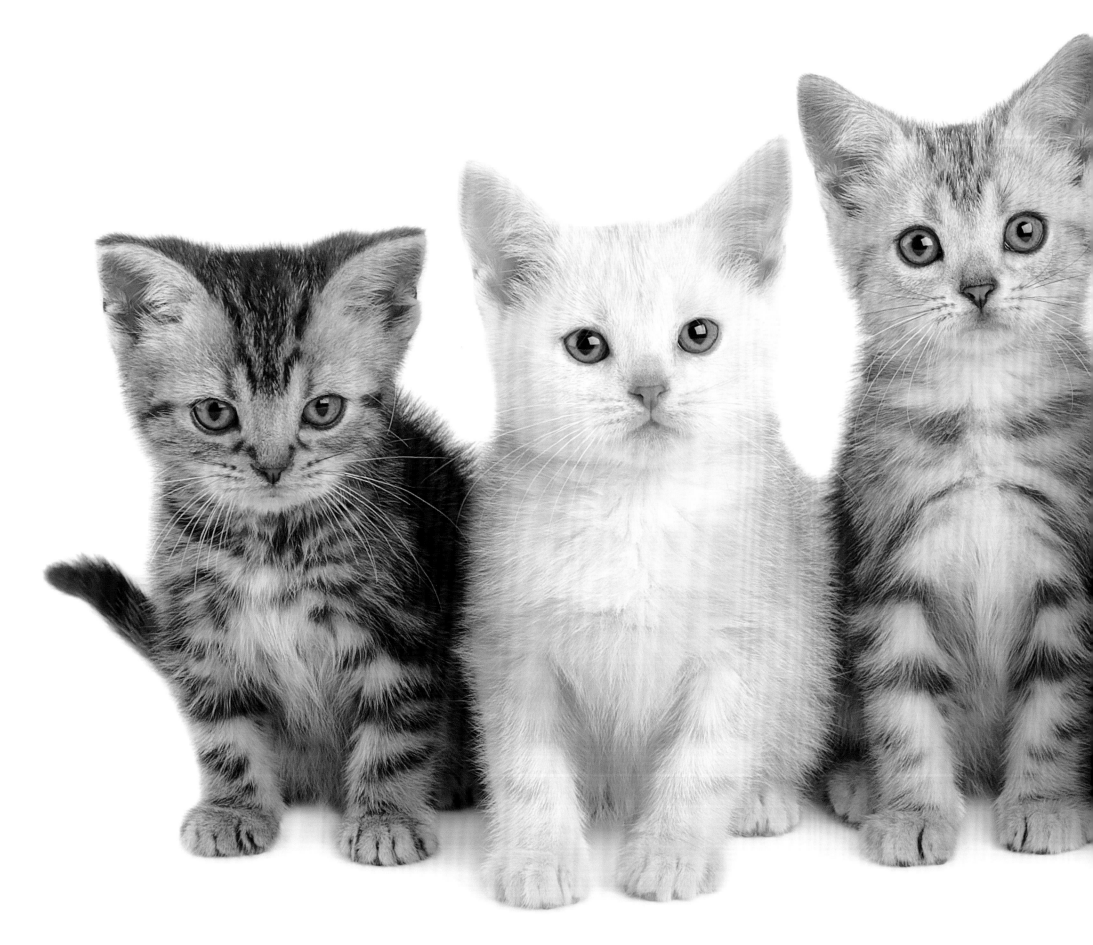

ABOVE: SILVER BOY, MR. KITTY, SILVER GIRL & PETUNIA

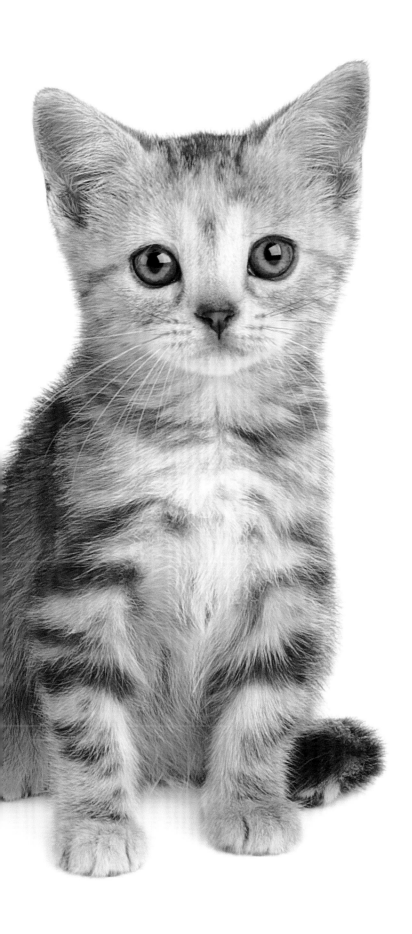

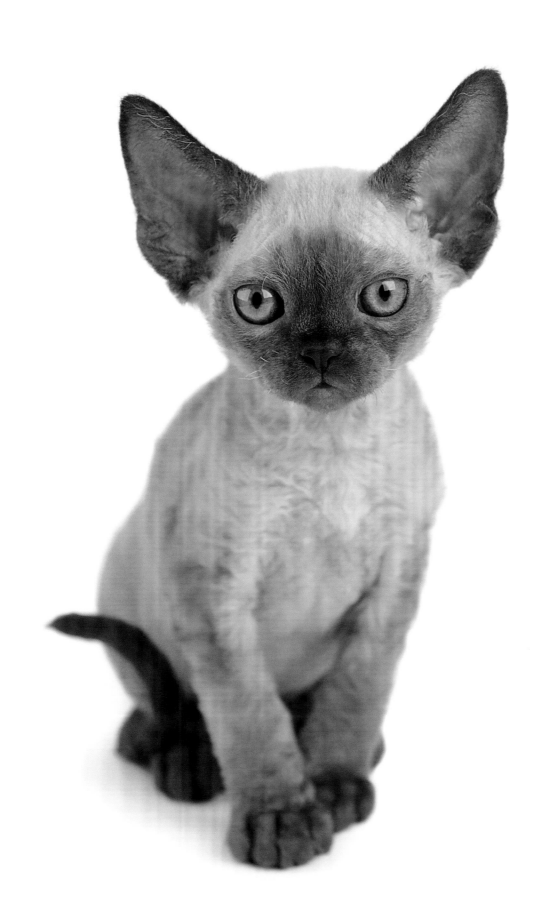

marvin | Devon Rex: 8 weeks, 2 lbs

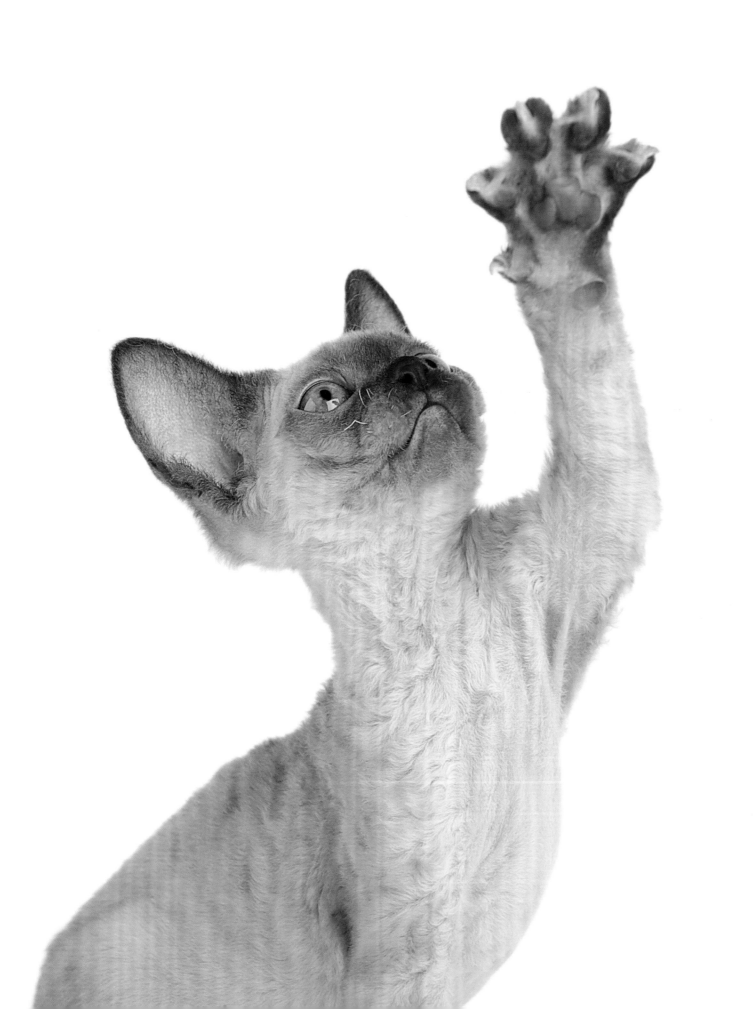

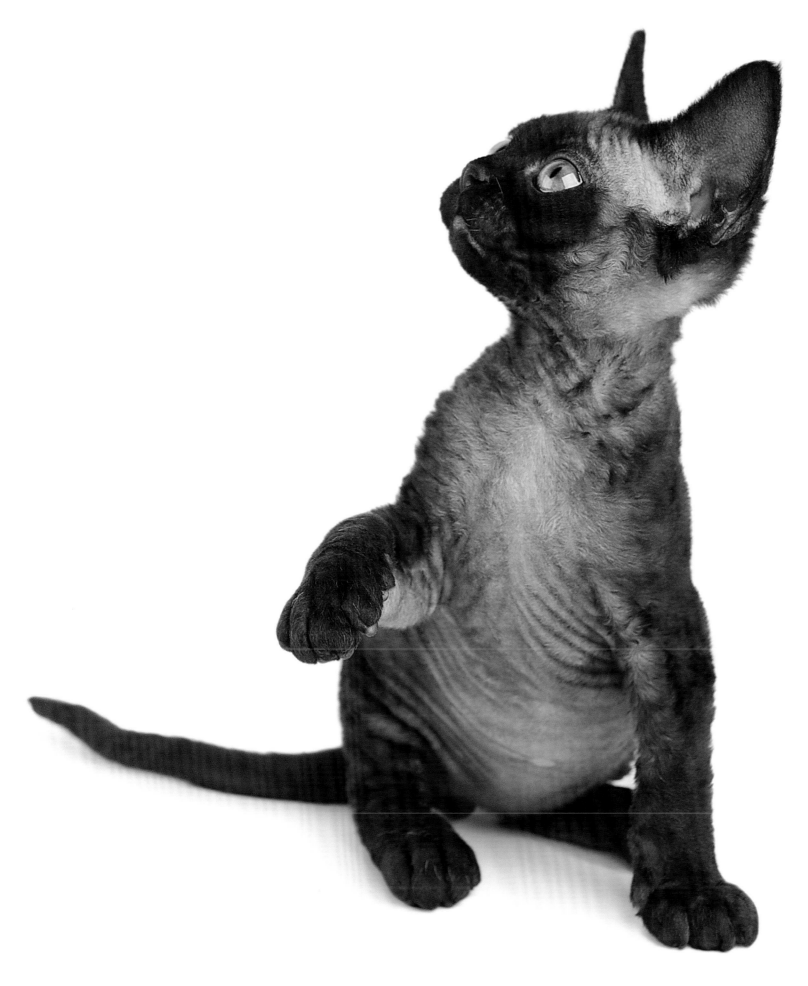

OPPOSITE: MARVIN ABOVE: GRACE

sally | Tabby Mix: 8 weeks, 2 lbs

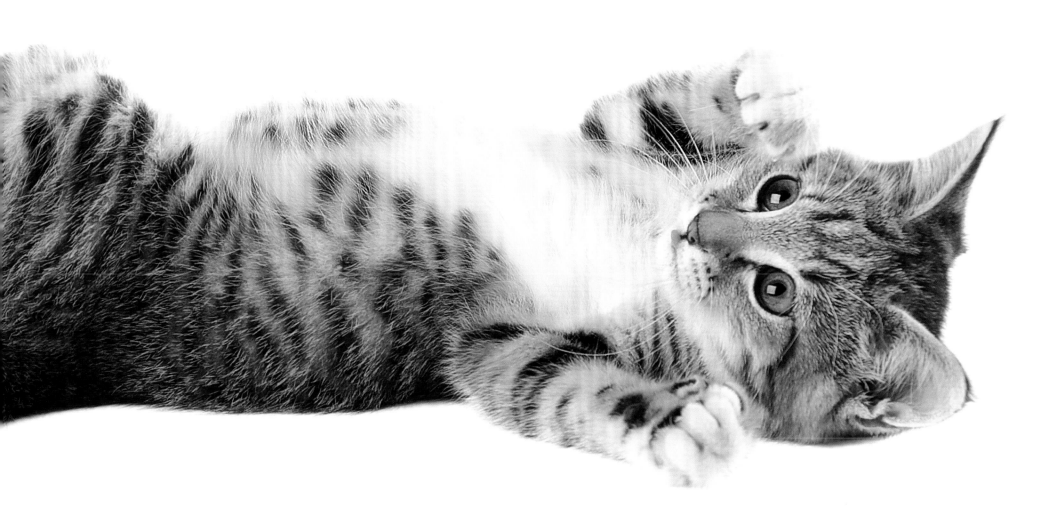

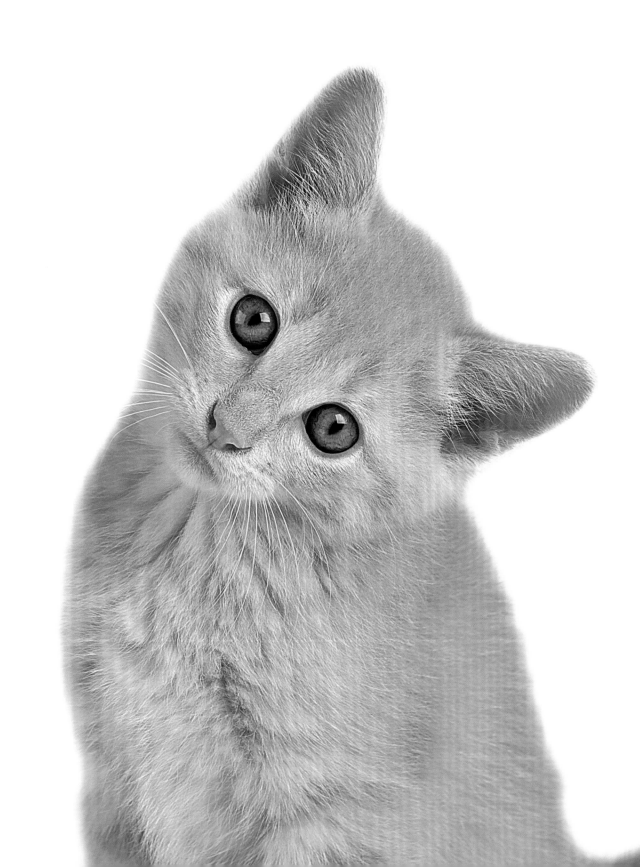

ABOVE: BUTTERS, 12 WEEKS OPPOSITE: SISSY, 3 WEEKS

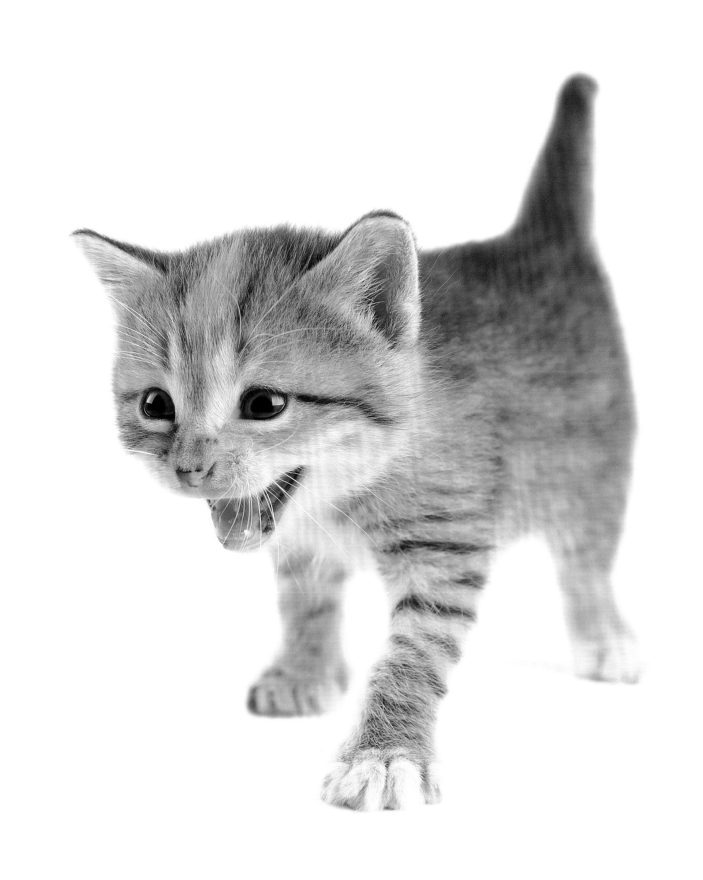

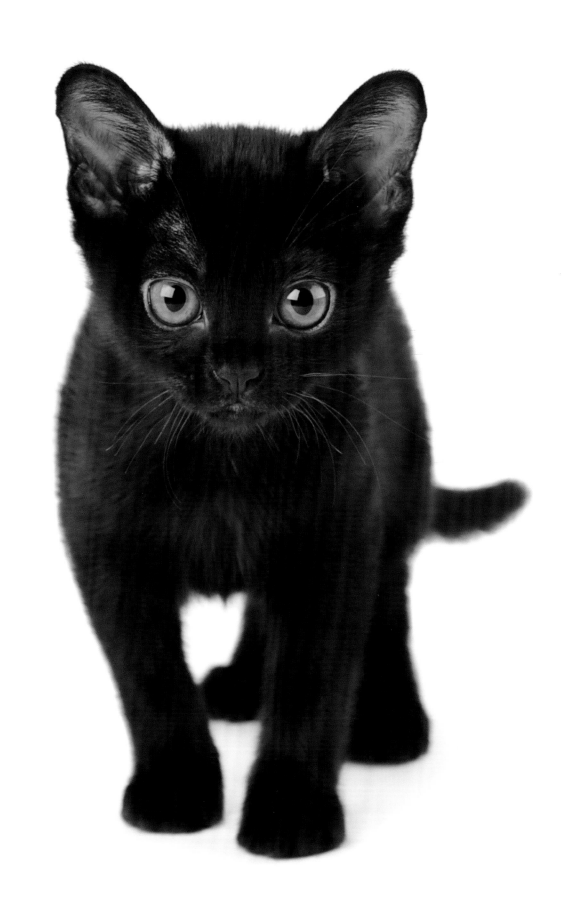

jojo | Bombay: 11 weeks, 2.5 lbs

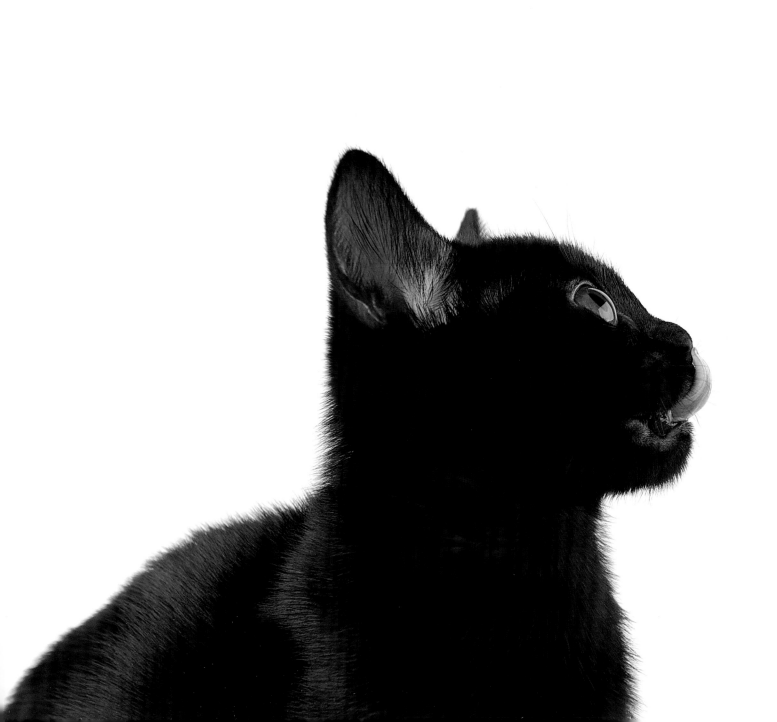

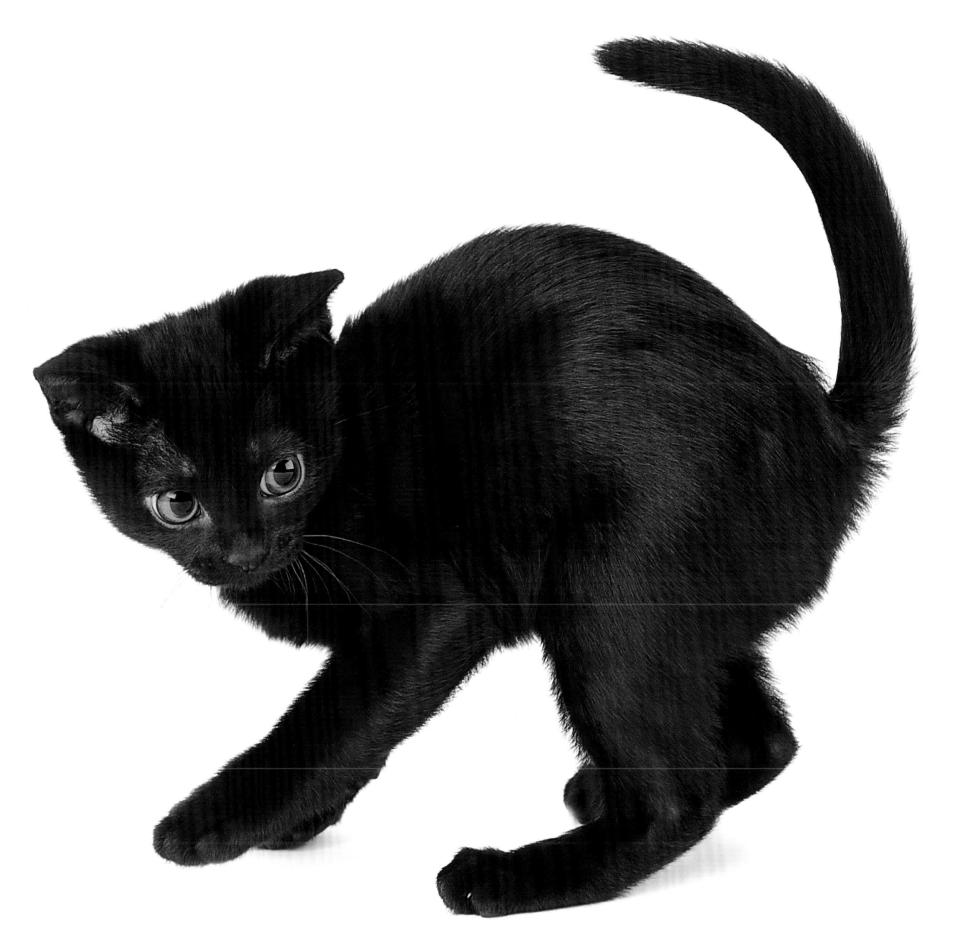

OPPOSITE: JOJO ABOVE: ADAM

diamond | Persian: 7 weeks, 1.5 lbs

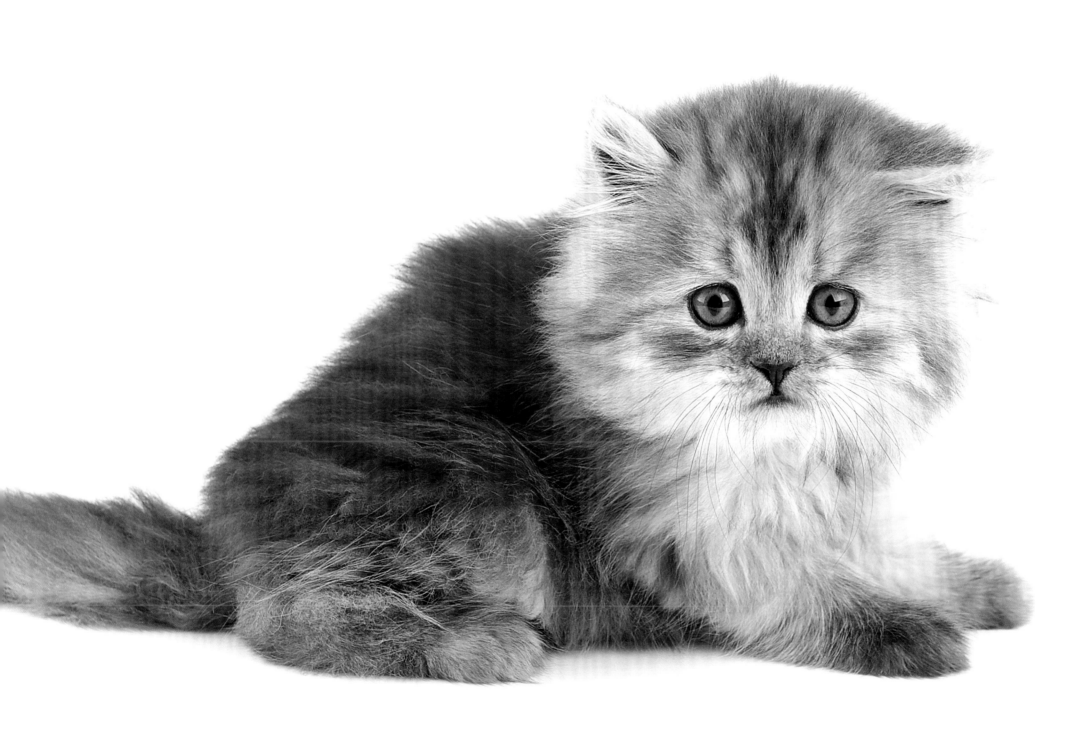

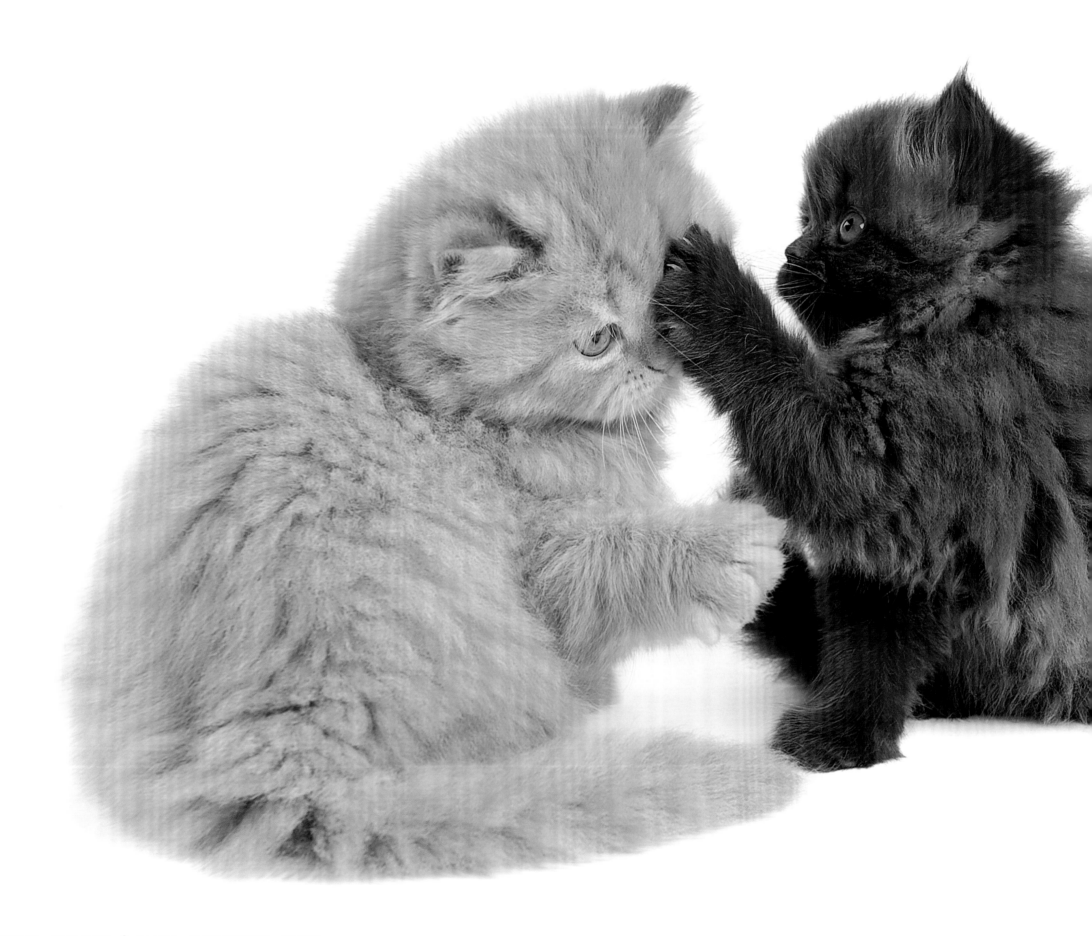

ABOVE: TIGGER & RUBY OPPOSITE: RUBY

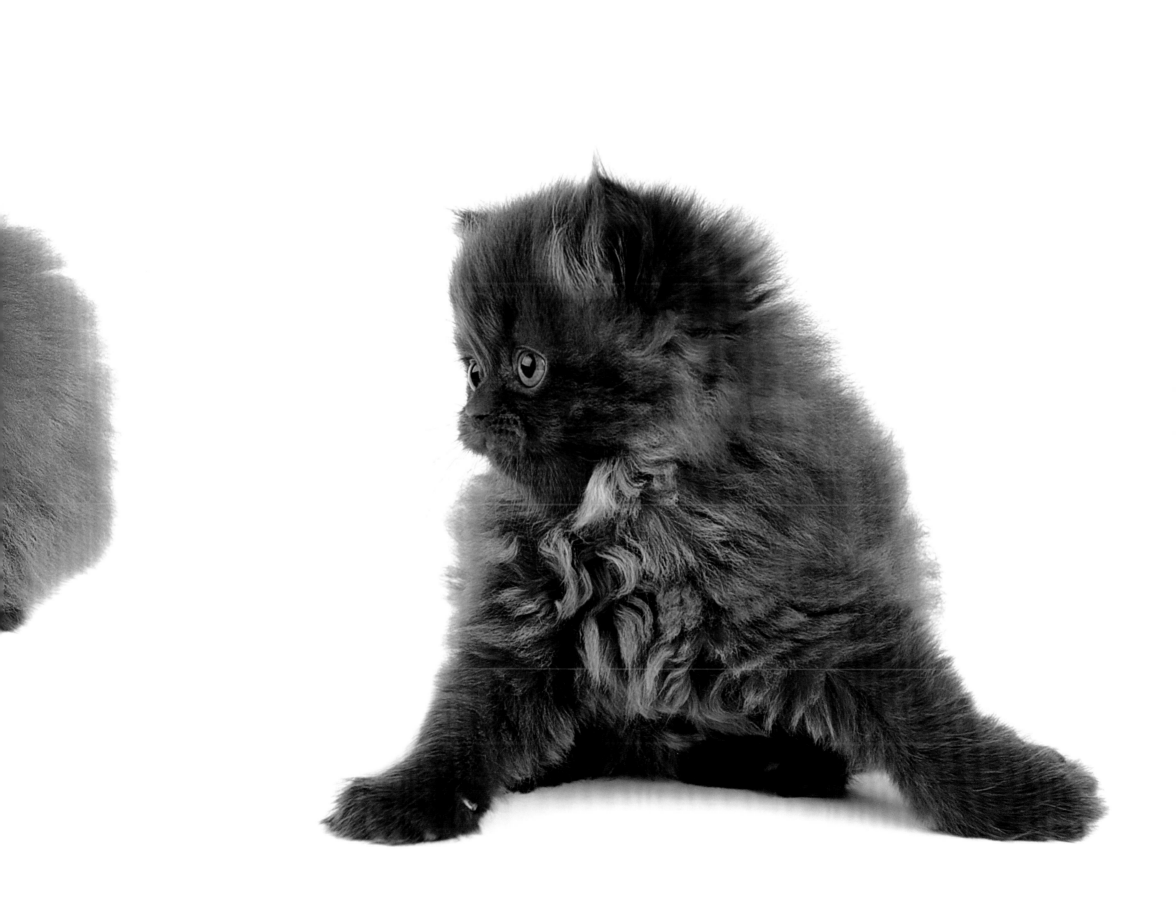

the process

Our mission: to find and photograph twenty-five different types of kittens twelve weeks old or younger.

Step one: Find the kittens.

We found that many shelters are overflowing with stray, mixed-breed cats and kittens, but purebred cats are surprisingly difficult to come by. There seem to be far fewer cat breeders than dog breeders in the Upper Midwest. Given the time frame of this project, not all breeders we found had kittens that fit in our age range, and some didn't have kittens at all. Developmentally, some purebreds are quite different than barn cats and mixed breeds, and they're officially considered kittens until six months. Their immune systems are fragile, they tend to develop at a slower rate, and there's a chance that some or all of any given litter may not survive their first few weeks. We were grateful to be trusted and welcomed into so many breeders' homes during this vulnerable time.

Step two: Photograph the kittens.

I've photographed many types of animals in my career—dogs, cats, rabbits, horses, lizards, ferrets, and chickens—and I've found that cats present a special challenge. Unlike dogs or puppies, cats and kittens are not necessarily treat motivated, they generally don't know commands or do tricks, and, at any given moment, they may very well want nothing to do with you. They can also be skittish, fast, and unpredictable. But I like to think I'm up to the challenge.

The younger kittens were the most challenging. They're still so small and learning about the world, and they don't (or physically can't) focus on treats or toys.

Another challenge was the activity level of the kittens. Kittens generally don't catnap unless they're in the comfort of their mother's curled-up body, a blanket, your lap, or each other's warmth. Very rarely would they calmly settle down for a snooze on the flat, hard paper background.

The most difficult part for me, while lying on the floor amid a flurry of cuteness, was trying to maintain camera focus on these small, fast-moving, unpredictable creatures. Reviewing the shots afterward was a roller coaster of anticipation, surprise, laughter, and heartbreak. There were some fantastic images I had no idea were captured and some that would have been amazing if only they were a little (or a lot) more in focus. Regardless, I found myself sporting a great big smile throughout most of the editing.

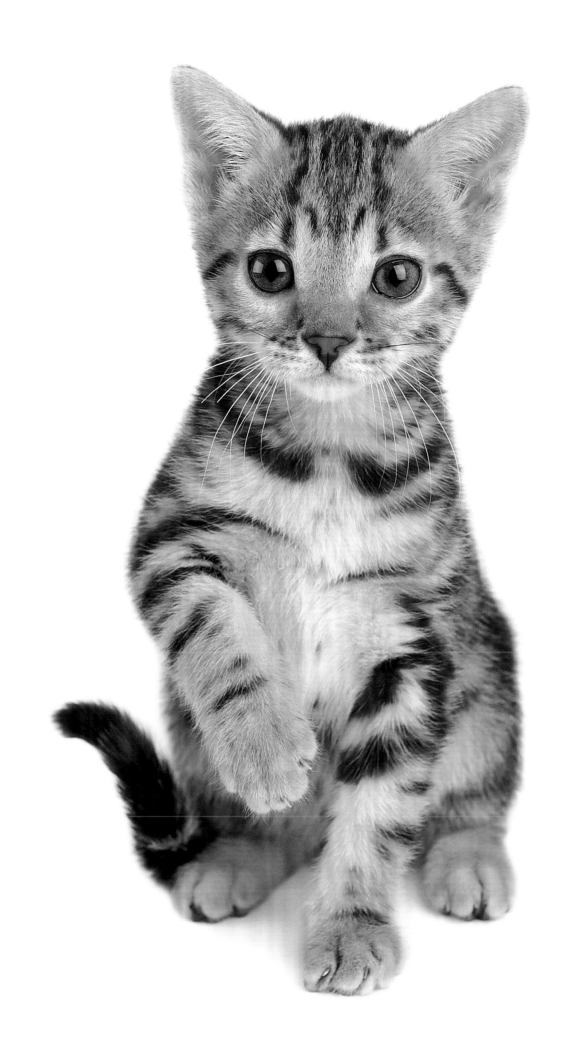

CALVIN

the contributors

We photographed both purebred kittens and mixed-breed rescue kittens for this book.

BREEDERS

We began our search with breeders who were part of the Cat Fanciers' Association and The International Cat Association. Both are great resources for learning about recognized purebreds, finding cat shows to attend in your area, and searching for breeders who adhere to the organizations' codes of ethics.

In searching for reputable breeders, we found that their receptiveness to the project and their complete willingness to invite us into their homes were great indicators that they had nothing to hide. I saw firsthand how well cared for these kittens were, and the breeders had strict protocols about their environment and food, and the health of the mother. Each breeder had a multitude of their own cats, with free reign over the house, all getting along well together and all being very comfortable with their owners.

Every breeder we met had an incredible love for their breed, and many have been breeding cats for a very long time. As with any group, the cat breeder community is tightly knit, and we were fortunate to receive recommendations from our participants for finding other breeds.

I learned a lot about the different breeds we photographed: temperaments, history, colorations, mutations, and what makes each one special. At first glance, some of the breeds may look similar, but they actually come from very different backgrounds or have branched off from other breeds. Many of the cat breeds we know today have existed for only a few decades. No matter which breed, these kittens will grow up to be gorgeous cats, living the good life as either champion show cats or beloved pets.

As purebred cats are relatively rare, most of the kittens we photographed were already spoken for at the time of the photo shoot (some even before they were born!). Personally, I was most smitten with the Cornish Rexes and Devon Rexes (which are not at all related to each other). Their exotic faces, eerily defined toes, tight, wavy coats, crinkly whiskers, and clownish personalities won me over instantly. I'm not in

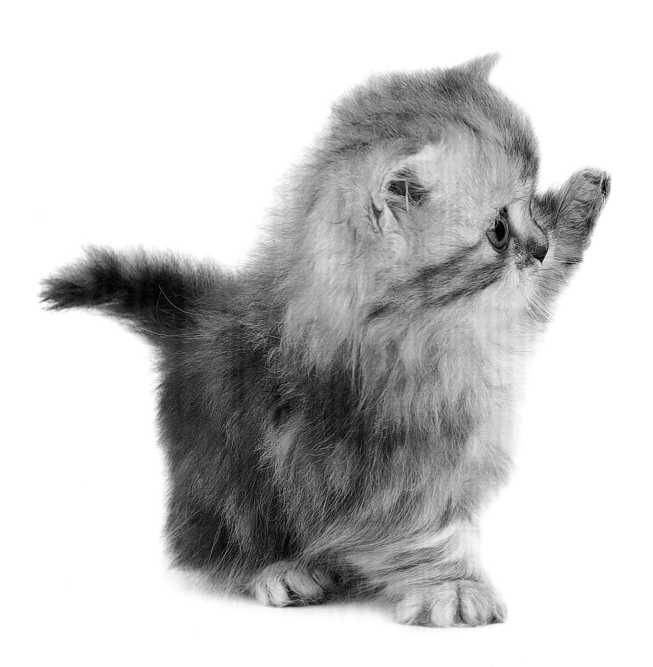

the market for any additional cats, but I was delighted that my assistant, Mary, ended up taking home two Cornish Rexes. They're weird and wonderful and a perfect fit for her family.

Below are the breeders whose kittens are featured in these pages.

american curl
WHSPRNWHSKRS Cattery, (262) 736-0176, http://www.whsprnwhskrs.com

american shorthair
Murrznpurrz, (262) 877-4352, http://www.murrznpurrz.webs.com

bengals
Ramatut Bengals, (763) 577-1636, http://www.ramatut.com

birman
Kats Kits, (651) 463-4780, http://www.katskits.com

bombay
Great Black Bombays, greatblackbombays@gmail.com, http://www.greatblackbombays.com

burmese
Evita Burmese, (612) 423-9170, http://www.evitaburmese.net

cornish rex
Corn-Bred Cattery, (952) 925-4711, http://www.cornbredcats.com

devon rex
Everafter Devons, (319) 551-7243, everafterdevons@aol.com

exotic longhair
Lumeria Exotics, (612) 867-5191, lumeriaexotics@yahoo.com

himalayan persian
La Bella Luna Persians, (507) 589-5314, http://labellalunapersians.com

maine coon

Kats Kits, (651) 463-4780, http://www.katskits.com

napoleons

Blue Skies Napoleons, (815) 946-2182, http://www.blueskycats.com

ocicats

Starsnstripes Pixiebobs & Ocicats, (608) 359-3490, http://stars-n-stripes-pixie-bobs.com/Ocicats.html

orientals

SAHJA, (815) 877-8358, http://www.sahjasiamese.com

persian

La Bella Luna Persians, (507) 589-5314, http://labellalunapersians.com

ragamuffin

Imperial Rags, (952) 994-8221, http://www.imperialrags.com

ragdolls

Arctic Blue Ragdolls, (763) 421-8254, http://www.arcticblueragdolls.com

selkirk rex

Nite Wind Selkirk Rex, (608) 296-4080, http://www.homestead.com/nitewindcattery

siamese

Koblizek Siamese, (715) 339-6444, http://www.koblizeksiamese.com

siberians

Heavnzsent Siberians, (262) 567-9773, http://www.shellyscats.com

sphynx

Katteycasa Sphynx, (218) 330-0476, http://www.katteycasa.com

tonkinese

Tipsycats Tonkinese, http://www.theatricats.com

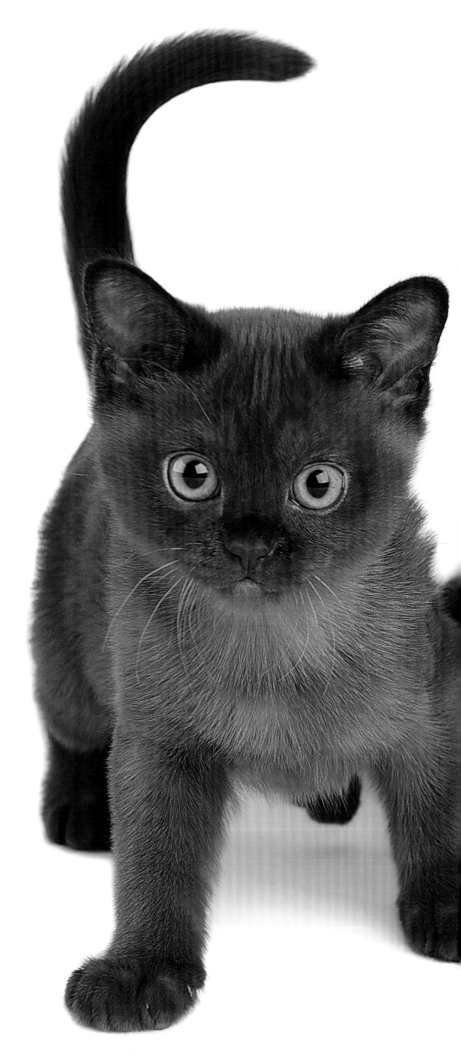

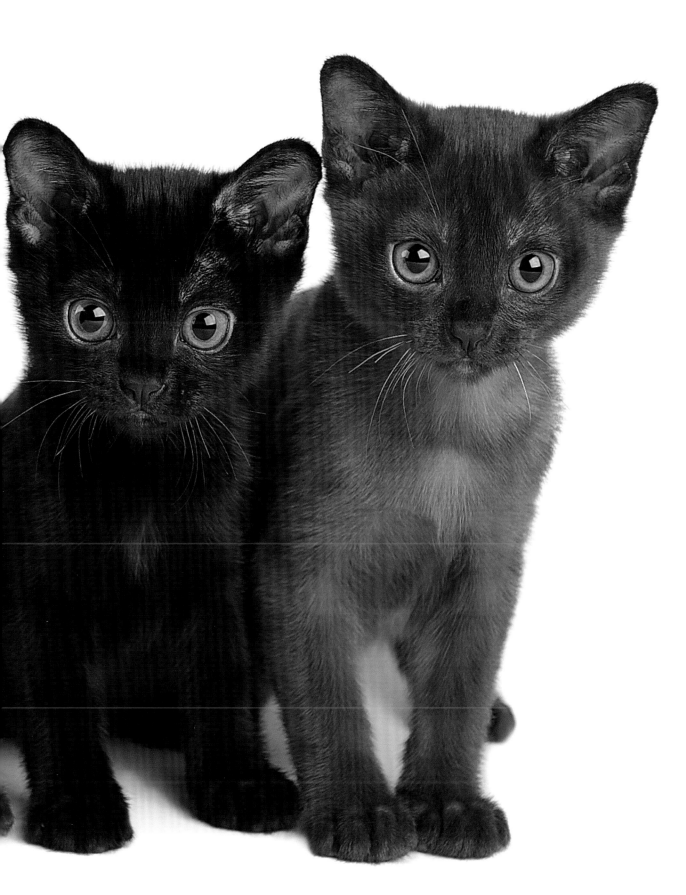

RESCUES

Mixed-breed kittens come in a hodgepodge of colors and patterns, but most fall into distinctive groupings: striped tabbies (which come in ticked and classic patterns), patchwork-coated calicos and tortoiseshells (or torties), dapper black-and-white tuxedos, and the classic black cat.

I work with many local rescues, and turned to some trusted friends in the industry to procure the mixed-breed kittens for the book. Secondhand Hounds primarily works with dogs (as their name suggests), but they happened to have two perfect tortie kittens at just the right time. Pet Project Rescue is one of my all-time favorite organizations. They are active with spay and neuter programs in our community and in poor areas of Mexico that need help controlling their animal populations. They also have a trap-neuter-release program for stray cats.

Purebreds do find their way into shelters as well, and sometimes coloring or characteristics of purebreds will show up in a mixed breed. Even at our barn, born from tabbies and calicos, we got a couple of seal point kittens, perhaps from Siamese or Birman DNA somewhere down the line.

There are also rescue organizations that take in only purebred cats, either in collaboration with other rescues or through owner surrender. The largest of these in the Midwest is Specialty Purebred Cat Rescue (http://www.purebredcatrescue.org).

Below are the rescue organizations whose kittens appear in the book.

black mix
Curt Baker, http://thekittensareborn.tumblr.com

tabby mix
Curt Baker, http://thekittensareborn.tumblr.com
Pet Project Rescue, http://www.petprojectrescue.com

tortoiseshell mix
Curt Baker, http://thekittensareborn.tumblr.com
Secondhand Hounds, http://secondhandhounds.org

tuxedo mix
Curt Baker, http://thekittensareborn.tumblr.com
Pet Project Rescue, http://www.petprojectrescue.com

finding your kitten

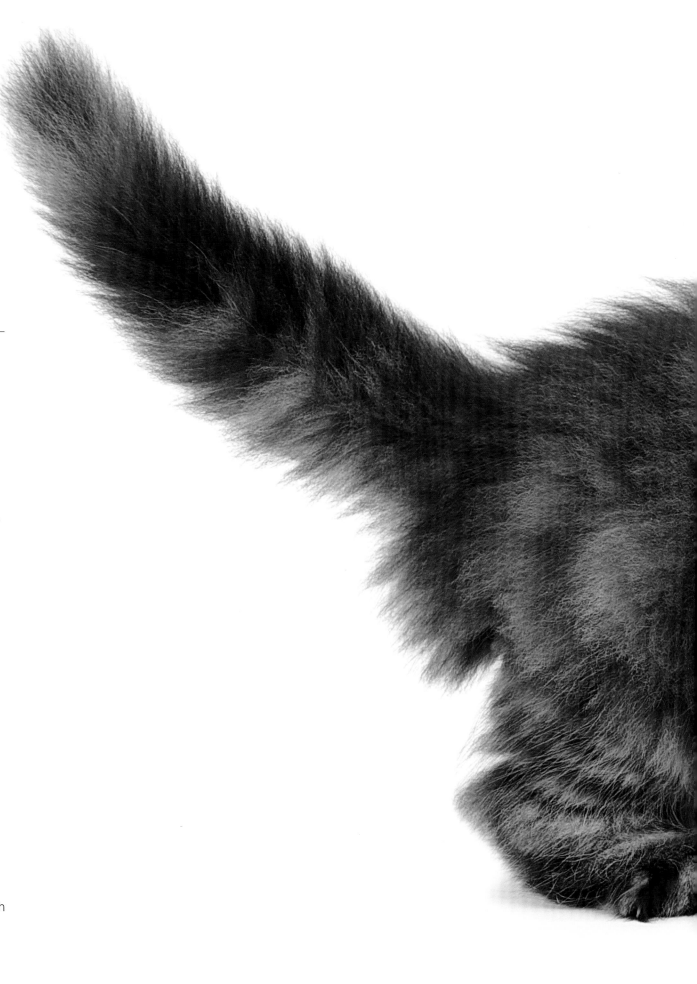

PUREBRED KITTENS

The first step in finding purebred kittens is to find a reputable breeder. The Cat Fanciers' Association and The International Cat Association have websites with listings of breeders who adhere to the organizations' codes of ethics and have pedigreed cats.

Unfortunately, "kitten mills" do exist—just like the more widely recognized "puppy mills." Such breeders do not take proper care of their animals: They keep far too many animals, usually caged in deplorable conditions with no exercise or socialization, and will readily sell kittens that are diseased, neglected, or have genetic defects. Reputable breeders will only place cats or kittens with a contract that includes a health guarantee and return policy, with the breeder taking responsibility if something should go wrong. They will be well informed about the breed and should be able to answer any questions you may have. Reputable breeders keep their cats clean, healthy, and well socialized. When possible, visit the breeder's home or cattery to meet the people and cats firsthand and ask for testimonials from people who have purchased cats from them in the past. Reputable breeders will only sell directly, never through pet stores, and generally not through places like Craigslist.

the cat fanciers' association

http://www.cfainc.org

The CFA offers a large registry of pedigreed cats. Their website has comprehensive information about breeds, a breeder referral service with tips on finding your kitten, information about upcoming cat shows, and much more.

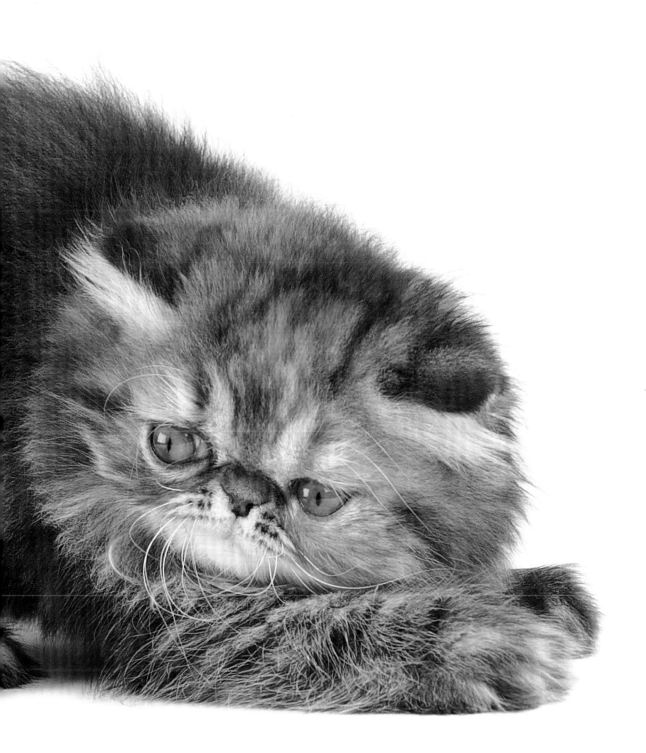

the international cat association

http://www.tica.org

TICA also has a huge registry of cat breeds. Filled with information about breeds and breeders, it's another great place to begin your research.

RESCUES AND SHELTERS

You can search many websites for available pets at rescue organizations near you. Many rescues will only adopt out to people living within a certain radius of the shelter, but if you find an animal in another state that you're interested in adopting, you may be able to team up with your local rescue to bring that animal to you, or travel to them yourself.

american society for the prevention of cruelty to animals

http://www.aspca.org

ASPCA is a wonderful humane organization with branches throughout the country. Visit their website for adoption and pet care tips. You can also search for adoptable pets in your area.

adopt-a-pet.com

http://www.adoptapet.com

This nonprofit charity website helps shelters, rescue groups, and other pet adoption organizations advertise their available pets.

petfinder

http://www.petfinder.com

Petfinder has a large, easily searchable database of pets available for adoption. It also provides contact information for rescues and shelters throughout North America.

To find local rescues, ask veterinarians or employees at other pet-related businesses to see who comes recommended and who doesn't. Not all rescues are run the same way, and though we hope that they all have the animals' best interests in mind, that may not always be the case. Consider these questions when thinking about adopting from a shelter:

- Do they spay or neuter the animal before adoption?

- Will they be sure it's up-to-date with vaccinations and is being sent home with a clean bill of health?

- What sort of guarantees or return policies do they have?

- Do they only take in and adopt out cute kittens, or do they reach out to the harder-to-adopt cases: elderly, disabled, and special needs cats?

FOSTERING, VOLUNTEERING, AND DONATING

If you'd like to help reputable rescue organizations and their animals, but aren't looking to adopt, consider becoming a foster home. With the seemingly endless supply of homeless pets, rescues can always use more people willing to temporarily house and care for adoptable animals until they find their forever homes. Rescues will generally cover costs for any veterinary care and even food or toys. Contact local rescues to find out more about opportunities in your area.

As nonprofits with continual costs for vet care, medicine, food, litter, administrative duties, and more, many rescue organizations will also graciously accept volunteers or donations. While the large national groups get lots of publicity and are doing good things, your money will

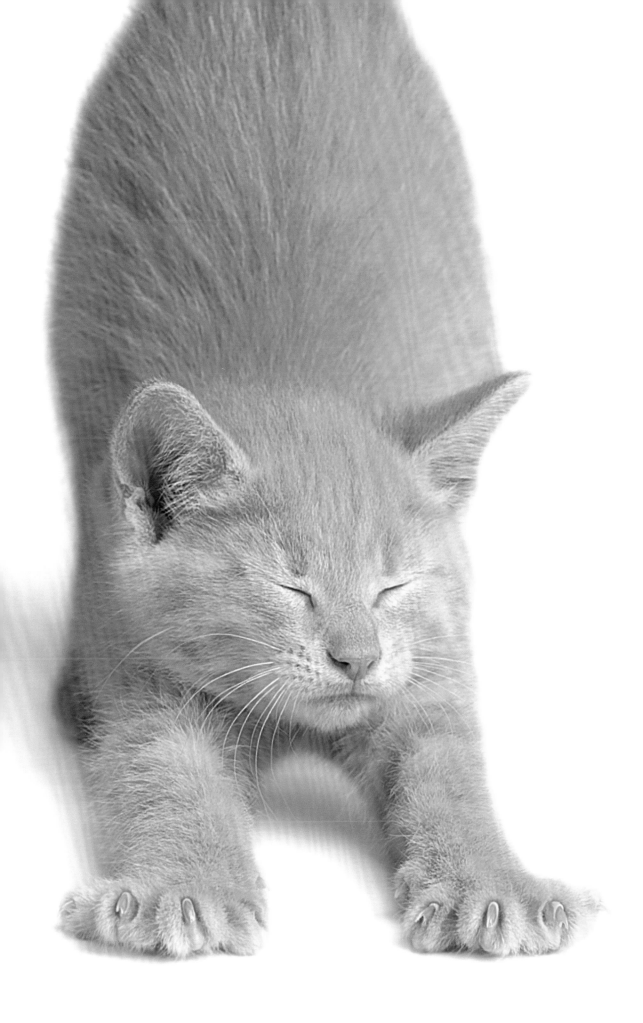

go further if you can contribute to a trusted, local group with lower over-head and advertising costs. Organizations will sometimes take in special cases that need extensive veterinary care, ongoing rehabilitation, or even a wheelchair, and they'll hold fund-raising events where your money will go directly to that cause. Some groups offer a sponsorship program, so if you have a soft spot for a particular animal, you can be sure that your donation is going toward the care of that one animal and not being disbursed for other purposes.

If you would like to donate to a larger, national organization, I think petsmartcharities.org is a great one. To check on the transparency of a national charity and see what percentage of your fund-raising dollar is going to the program versus other costs like salaries or advertising, you can do a search on Charity Navigator (http://charitynavigator.org).

At the end of the day, whether purchasing from a breeder or a rescue organization, follow your heart and your values, do your research, and make informed decisions. Remember that you're committing to caring for another living being for ten to twenty years.

I'm happy to say that I've encountered some really great people on both the breeder and the rescue sides of companion animals. Just be smart about what you're getting into, and try not to fall for the first fuzzy face that melts your heart. Research breeds to see which temperament or size or length of fur is best for your home and lifestyle. Be aware that the financial investment doesn't end with the purchase price or adoption fee. Your new kitten will need high-quality food and vet care to maintain a long, healthy life. Kittens need toys to keep occupied, plenty of clean litter, and clippers to trim their nails. Also, scratching posts are vital when it comes to saving your furniture (and your sanity!).

BUTTERS

acknowledgments

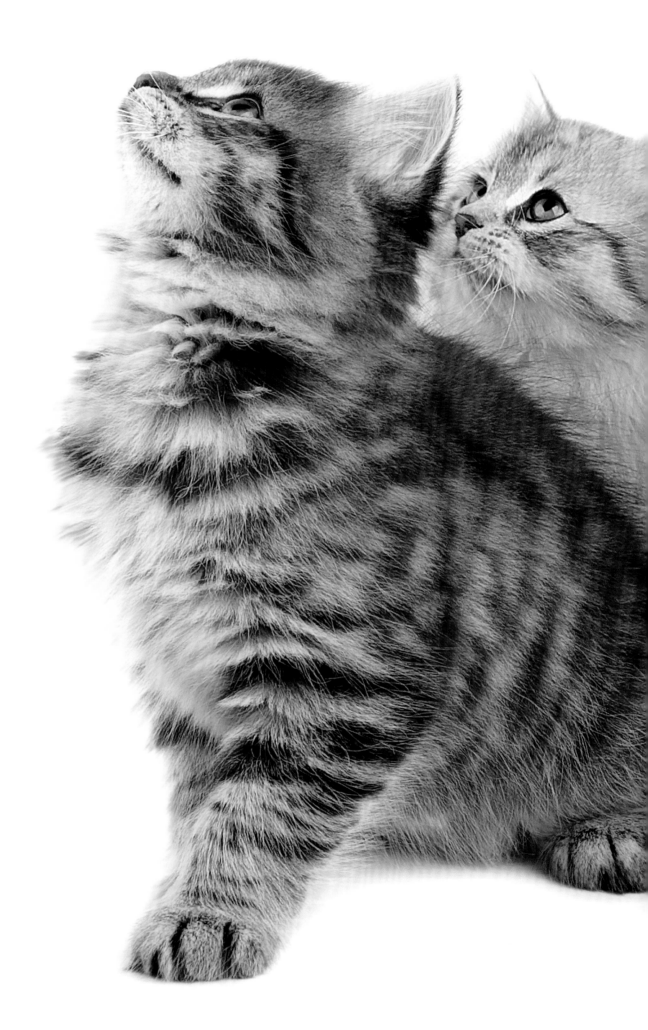

Thank you to becker&mayer! and Stewart, Tabori & Chang for consider-
ing me for this publication! It's been a long, fun, and rewarding journey.
A huge thank-you to my assistant, Mary Ludington. She did an amazing
job of tracking down and corresponding with all these breeders. She
arranged the photo shoots and developed my travel itinerary for all the
out-of-town destinations. She, along with my other fabulous assistants,
Heather Everhart and Dustin Marks, were invaluable at the shoots them-
selves and in the long car rides to and from participants' homes. Herding
cats, as they say, is no easy task, and their expert kitten wrangling and
toy dangling made my job easy and fun. You guys are the best! Thank you
to Michael Devons for accompanying us and shooting some fantastic
video. Thank you to all the wonderful breeders and rescues who partici-
pated in the project; it was great meeting all of you! I'm so excited to
have been a part of this, and you've whetted my appetite for many more
projects like this in the future.

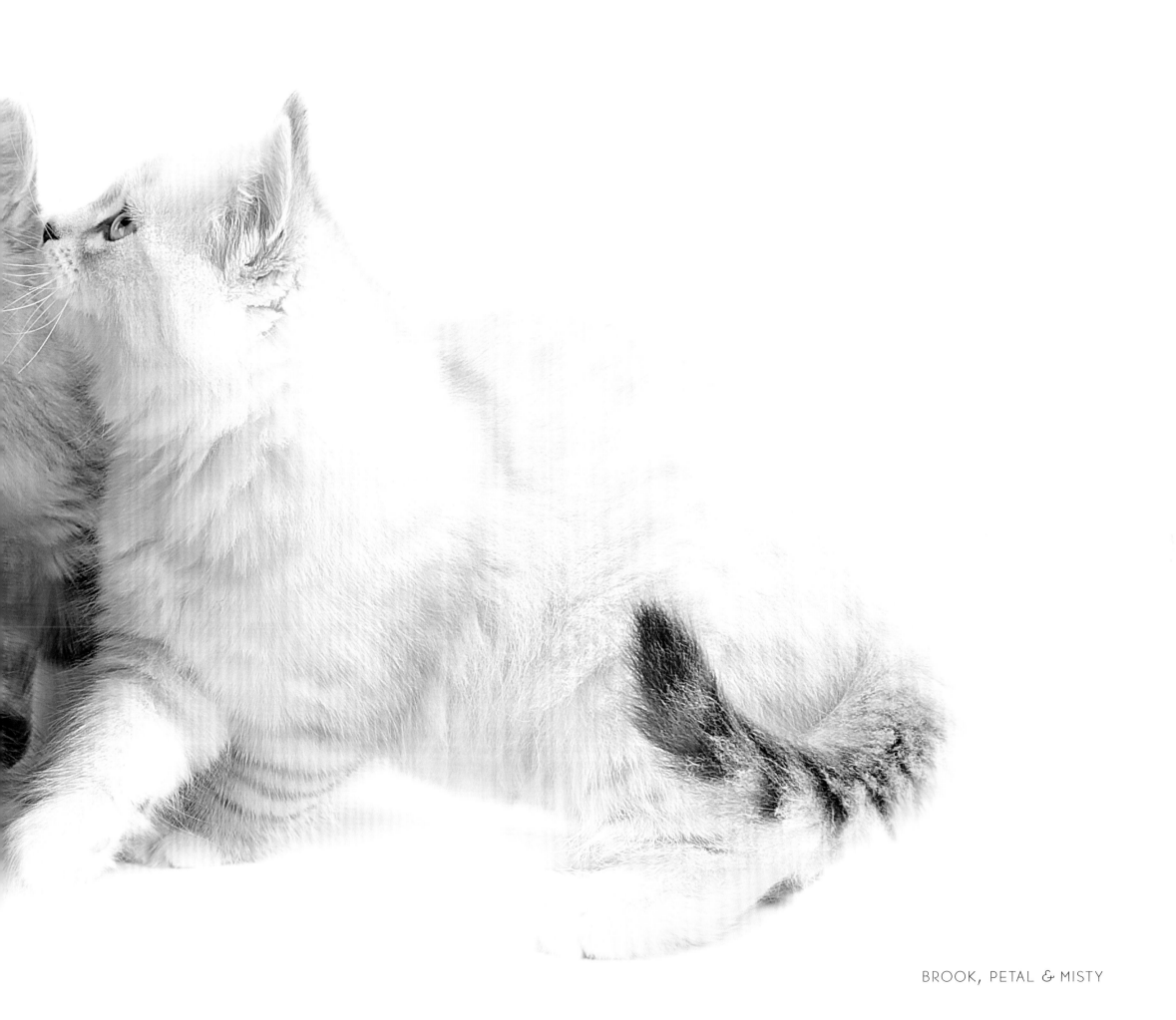

BROOK, PETAL & MISTY

about the author

Sarah Beth Ernhart is a renowned pet photographer in Minneapolis, Minnesota. She specializes in fun, modern studio images that capture the spirit and personality of pets. In addition, she's proud to offer her signature Joy Session® for terminally ill and elderly pets and has created joysession.com, a directory of pet photographers who offer similar services. She is an avid supporter of rescue and animal welfare organizations and donates a portion of all her client session revenue to a variety of nonprofits. Sarah Beth has been featured on the CBS Minnesota local news, in *Professional Photographer* magazine, *The Bark*, *Minnesota Monthly*, *Metro Magazine*, and many other blogs and publications. She's been named Best Pet Photographer in the Twin Cities multiple times, and was a winner in the 2012 PDN Faces Competition. Her work can be seen at many veterinary offices, dog daycares, and other pet businesses around the Minneapolis and St. Paul metro area. She shares her home with the wonderful, handsome, and always supportive Dustin Marks; two cats, Simon and Chippy; and Gracie the Miniature Schnauzer.

Visit http://sarahbethphotography.com to see more of Sarah's work. You can also contact her at info@sarahbethphotography.com.

ABOVE: SILLY FOLLOWING: MATTI & ALLISON

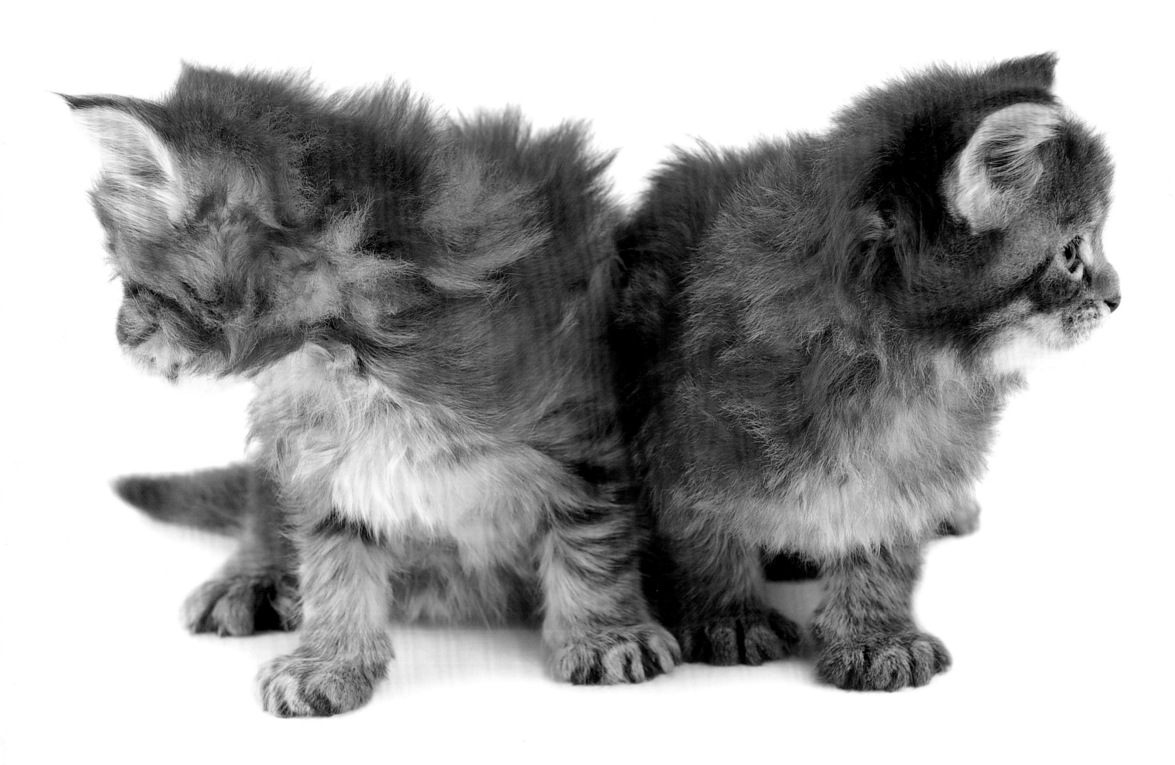